Valentin Carron

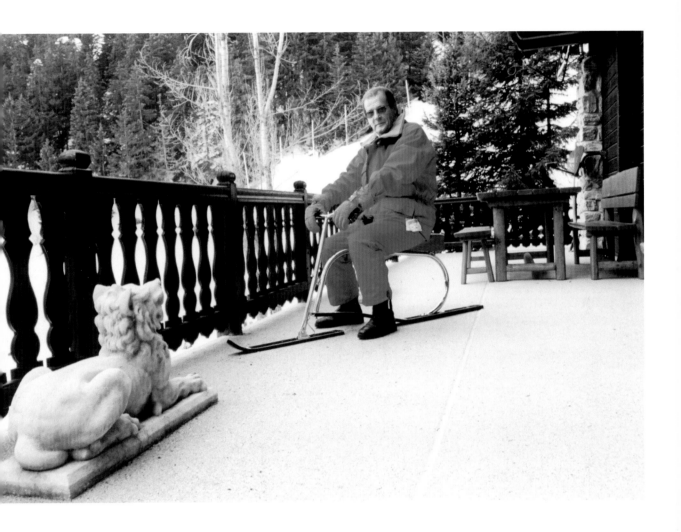

Kunsthalle Zürich
Centre d'art contemporain Genève

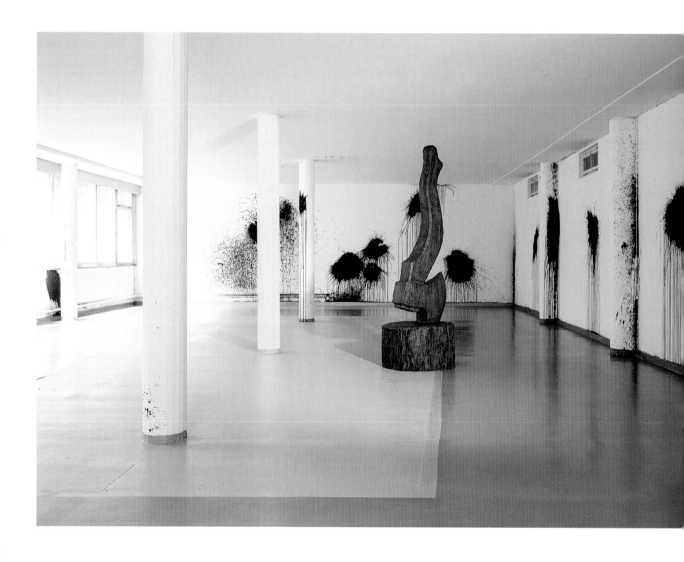

Installation view: *Fink Forward*
Kunsthaus Glarus, Glarus, 2003 [SWEET REVOLUTION 2, 2003]

2

Katya García-Antón & Beatrix Ruf

Valentin Carron makes sculptures that repeat, on a life-size scale, existing objects of vernacular significance, iconic art pieces, and public monuments. The works are cast in fiberglass resulting in a lightness and artificial texture at odds with their definite presence. And yet while Carron's sculptures may not be perceived as authentic, they can definitely be understood as "true." They propose a version of the present that combines the concreteness of everyday reality with the fictions employed in the construction of its identity. Indeed, Carron's sculptures correspond to the Coca-Cola concept of the "real thing" which, while it is a 100% artificial beverage, stands as the most real, recognizable symbol of American culture to date, aside from the national flag. It is, perhaps, no coincidence to discover that one of Carron's early works is also a pseudo-beverage with strong national connotations. Inspired by the Valais, a region that promotes itself as being the "real" Switzerland as well as being steeped in an ancient tradition of viticulture, *Château Synthèse*, 2000, was devised as a bottle of completely artificial wine made by chemical engineers of the Valais.

To invoke a cultural icon such as Coca-Cola during a discussion of Carron's work is to invite a consideration of the artist's practice as part and parcel of a contemporary tradition of Pop art. A tradition that can be used to explore how the notions of repetition, cultural banality, and consumption operate in his work. If a potted history of Pop begins with Marcel Duchamp's readymades, such a history reaches an inevitable conclusion with Andy Warhol's Brillo boxes, which perfectly imitated the readymade without actually becoming one. Duchamp and Warhol operated within the aesthetics of the banal and industrial manufacture, awarding the found item with that "plus" that Pierre Restany referred to when he coined the term "objet-plus" for the Pop objects made by the French New Realists. However, more pertinent to Carron's thinking than European Pop is the generation of American artists that followed Duchamp and Warhol, and who crossed over with other artistic strategies such as appropiationism and hyper-realism.

The works of Sturtevant and Duane Hanson are a good example, as they introduced high art and social disaffection, respectively, into the heart of the so-called "post-Pop" debate. In so doing they extended the field of possibilities for what was a consumable and banalized object within the material culture of the day. Sturtevant consecrated her career to repeating iconic works by Duchamp, Warhol, Lichtenstein, and Oldenburg, among others, exploring in the process notions of the replica, the simu-lacrum, the original, and the fake. Hanson, on the other hand, manufactured hyper-realist sculptural copies of disenfranchised individuals from the margins of American society.

Carron's practice builds upon this Pop lineage by referencing high art on the one hand and the notion of a cultural periphery on the other. Arguably, the hijacking of well-known artworks in Carron's œuvre may be genealogically connected to a practice of art historical Appropriationism characteristic of the 1980s. But while both Appropriationist artists such as Sturtevant and Sherrie Levine questioned ideas about authorship and originality, plagiarism and value, Carron's approach reveals a greater degree of conceptual and physical intervention that one could go as far as describing as a form of cultural re-enactment.[*]

On the one hand, are his "intervened" appropriations of iconic art of the 20th century. For example, Carron's *L'Homme*, 2006, recasts Giacometti's walking man, mid-stride and sporting an incongruous "up yours" arm gesture. On the other hand, the artist disrupts the concerted efforts to inscribe the Valais region within the grand narrative of history. *Lasciatemi vivere la mia vita*, 2005, is, as the artist describes in his interview with Fabrice Stroun, an unequivocal emblem of military, cultural, and historic power for the region. And lastly is Carron's hijacking of modernist iconography into a sort of Duanesque territory of marginality, such as that found in *Sweet Revolution*. This large sculpture is perceived at first glance as a sort of alpine-statuary-meets-modernist-public-sculpture. Yet on closer inspection we notice the discarded party poppers on the sculpture's base. A reference no doubt to the social disaffection encountered in suburbia, Swiss or other, and which so often leaves its traces in public spaces.

In his exhibition at the Kunsthalle, Carron goes more deeply into these aspects with installations, works displayed on walls, and sculptures which touch both on the surface and the "behind-the-walls" aspect of the "myths" described above, as they relate to his place of origin, Martigny. He does this by the repetition of public, decorative objects that are aestheticized in an ambivalent way through being displayed. For example, he exhibits the monumental installation *Rance Club II*, 2006, in which a carillon plays at regular intervals like a melody sounding from a long way off, a soundtrack that Carron compiled from the hymns sung by the French Resistance in World War II, and had played by the Martigny church bells. He locates this sound behind the walls of an inaccessible architectonic spatial construction which, with its rough plasterwork, offers us the horror of the surface aesthetics of a bygone era and concept. The Fondation Gianadda, important in attracting tourists to Martigny, plays a major role in the artist's work: it is a museum built above the remains of a Celtic temple that collects archaeological finds made in Martigny, as well as bringing whole busloads of people into the small town with temporary exhibitions devoted to classical modern art. It is an archive of originals and replicas and the deposits of historical artifacts the authenticity of which embraces the concept of both the original and the duplicate. In the objects made by Carron, the marketing of art for tourist purposes and the often dubious appropriation of its attractive-ness in the equally dubious approximation to art and works of art in the local production of objects and aesthetics, culminates in a production of "art" as a multiply overlaid field of likewise dubious reputations. As well as the form of the Cross, the "public" sculptural symbol of the western

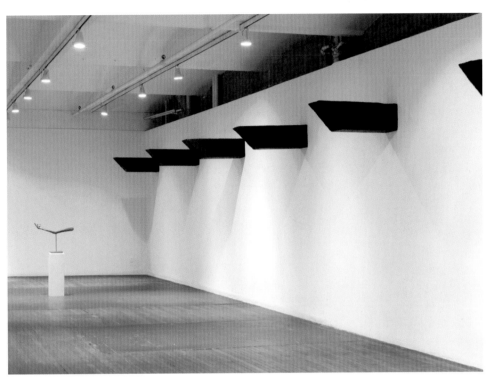

Installation view: *Déchéance, élégance, déhanchement*
Swiss Institute, New York, 2006

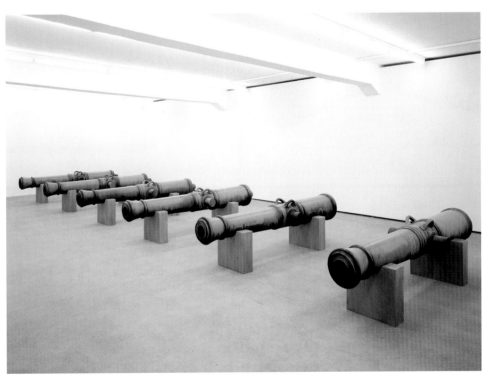

Installation view: *Rellik*
Galerie Eva Presenhuber, Zurich, 2005

Christian cultural area, but also the abstract relief formed by two intersecting lines, and hence the epitome of abstract art, Carron shows a large group of sculptures which relate directly or indirectly to works from the area of influence of this institution: *Captain Legacy*, 2006, repeats the fragment of a cast of the drapery on a Gallo-Roman marble statue held by the Foundation; *Untitled (Henry Moore)*, 2006, is derived from a sculpture by a local artist of the 1980s who was influenced by Henry Moore; while *Trikorn*, 2006, continues with the theme of repetition: the sculpture is based on a stone head by a local artist who in turn had fashioned it after a bronze sculpture at the Fondation Gianadda.

If the notion of re-enactment is to be introduced in Carron's work, it is by arguing that the activity of making art is itself a form of cultural production, and therefore a kind of historical re-enactment. In other words, Carron's methods, as those of other contemporary artists today employing re-enactment strategies, should be perceived as an activity that re-casts heritage through ritualized behavior.

*In his introduction to the volume of essays *Excavating Modernism*, Bernard Tschumi writes: "Ex-centric, dis-integrated, dis-located, dis-juncted, deconstructed, dismantled, dis-associated, dis-continuous, reregulated ... de-, dis-, ex-. These are the prefixes of today. Not post-, neo-, or pre-." With regard to the work of Valentin Carron, one should add "re-" to this list of prefixes from ten years ago: recycle, re-look, re-stage, re-think, re-build, re-turn, re-make, re-invention, repetition, or as Sturtevant said, "Remake, reuse, reassemble, recombine—that's the way to go."

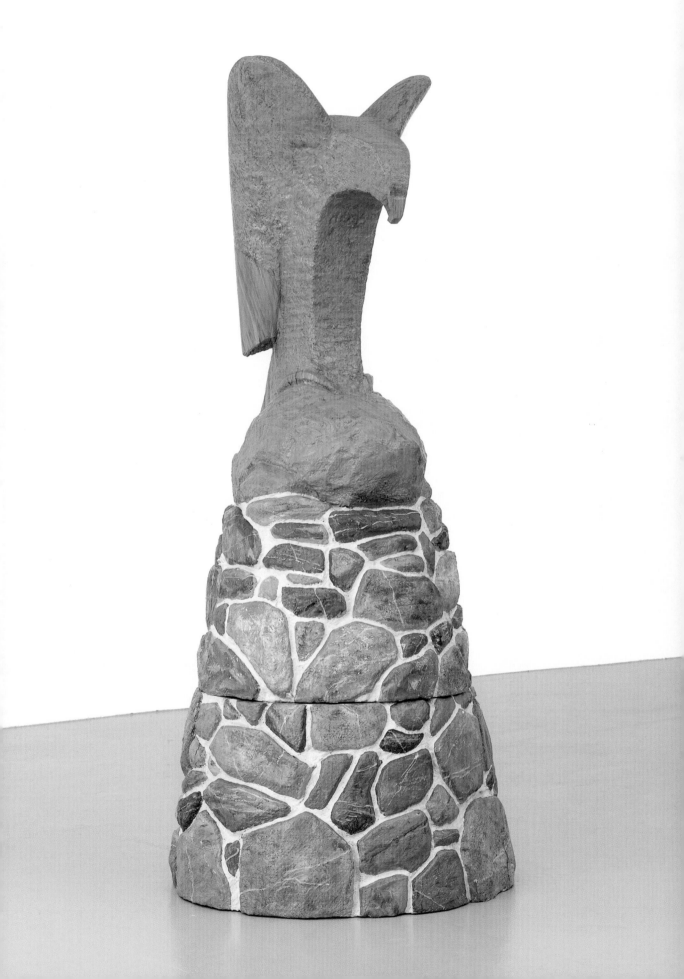

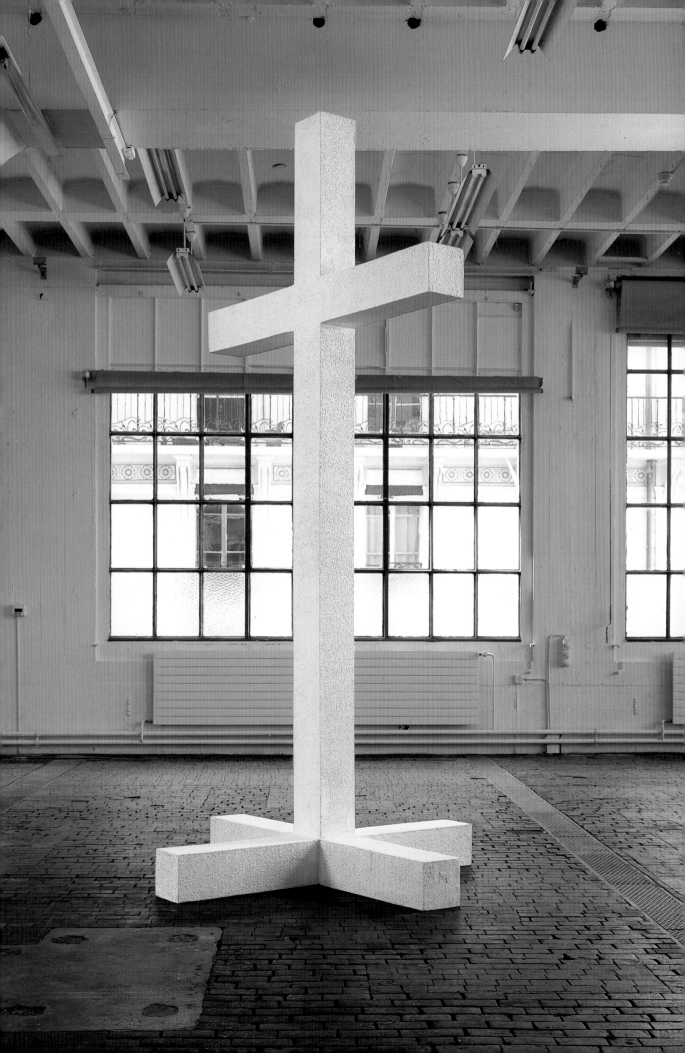

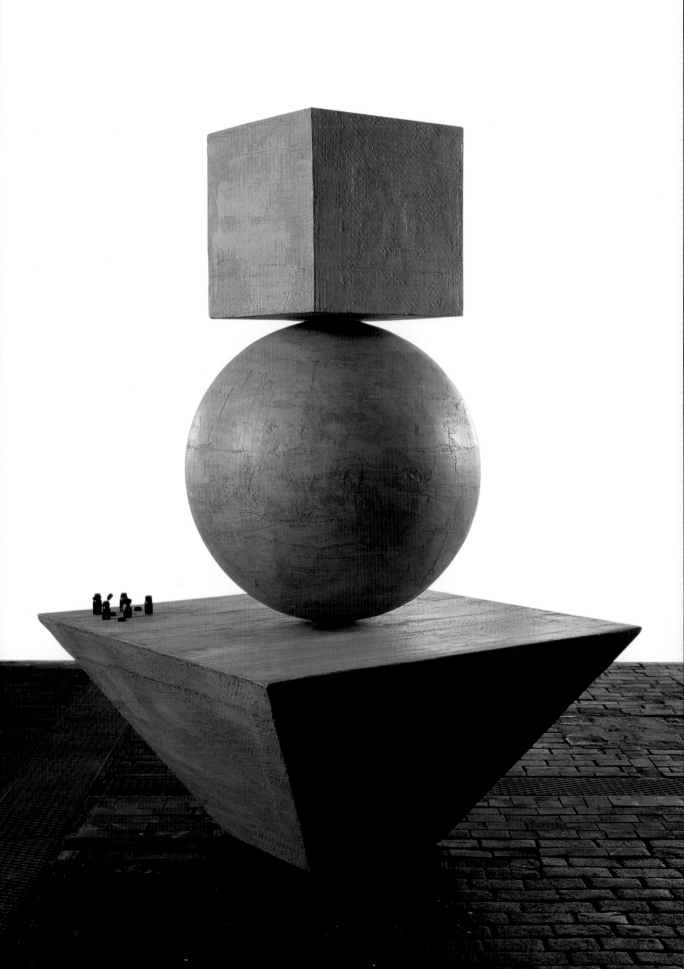

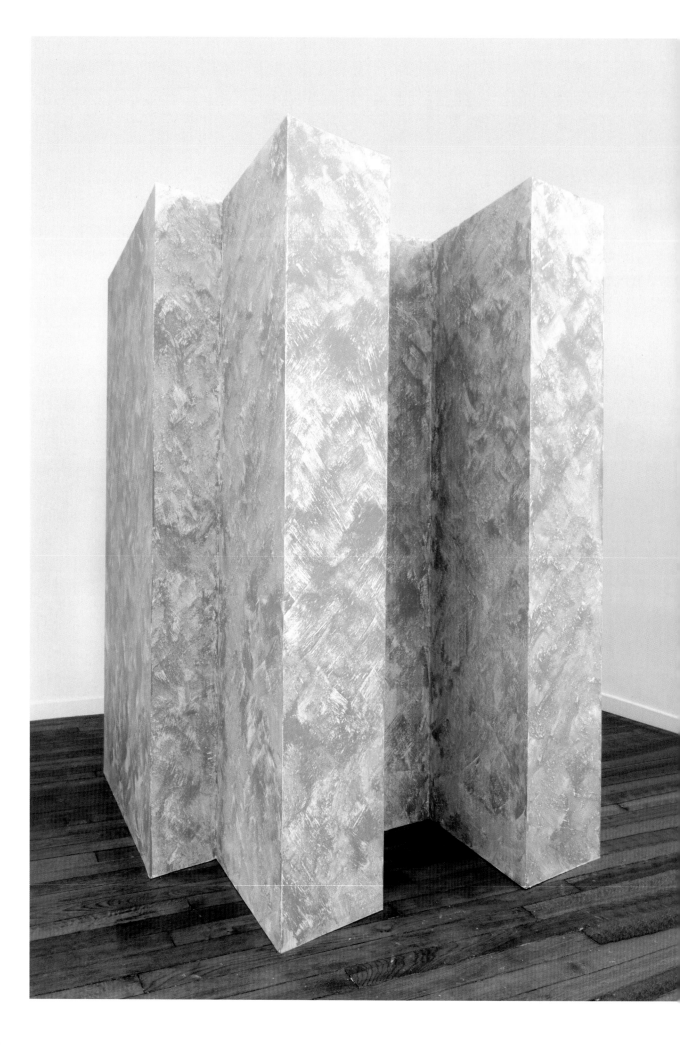

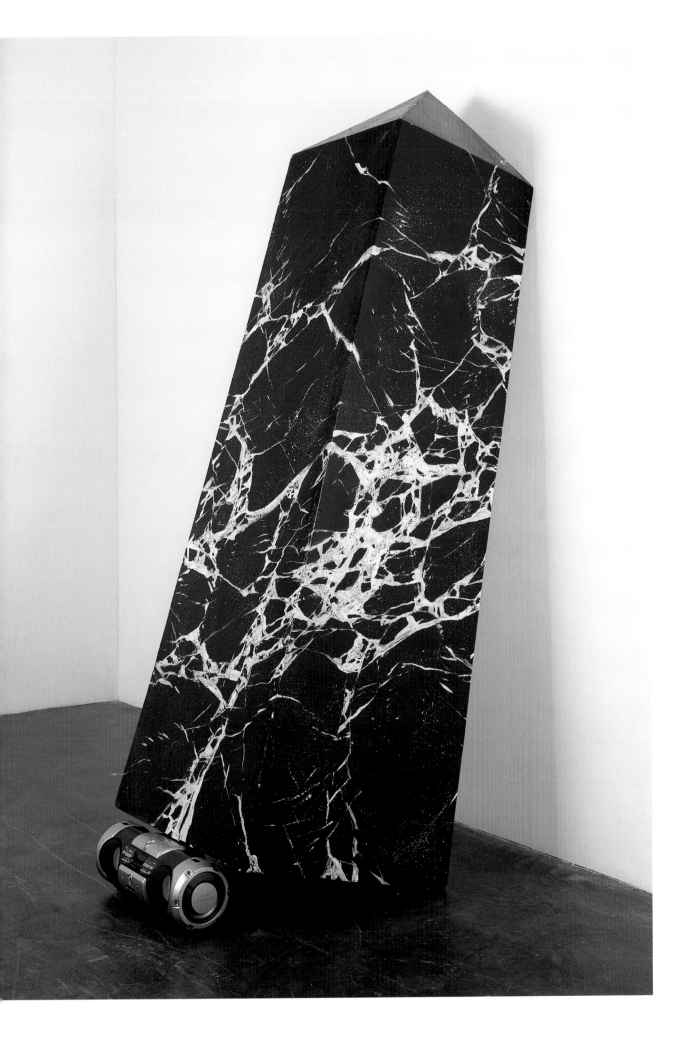

KISS, 2005
← ←

UNTITLED, 2003
←

KISS, 2005

BESTIAL DEVOTION, 2005

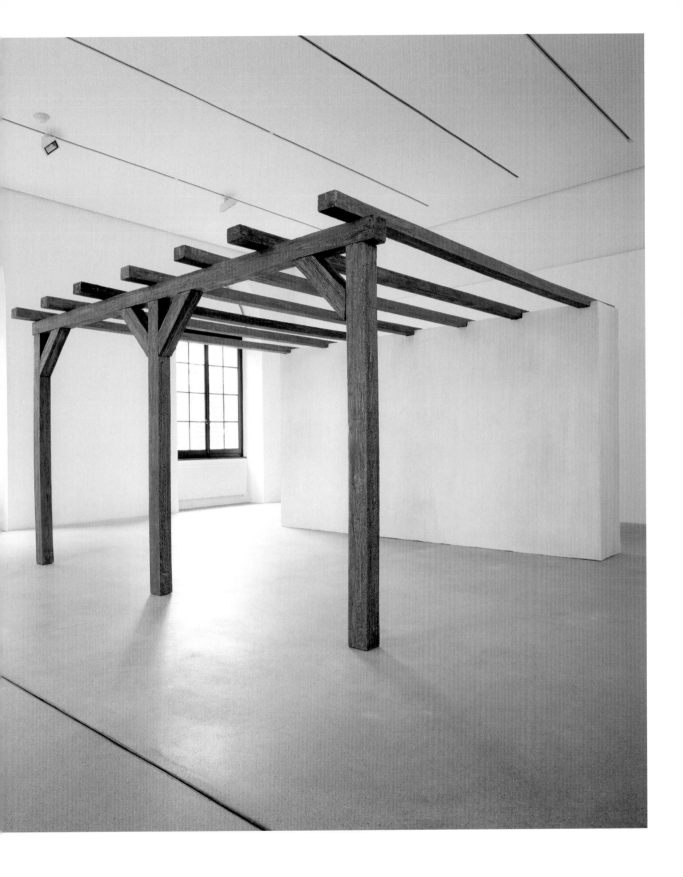

PERGOLA, 2001

RANCE CLUB II, 2006
← ←

BARRE BAR, 2005
←

Installation view: *After the hunting rush*
Circuit, Lausanne, 2002 [AFTER THE HUNTING RUSH, 2002]

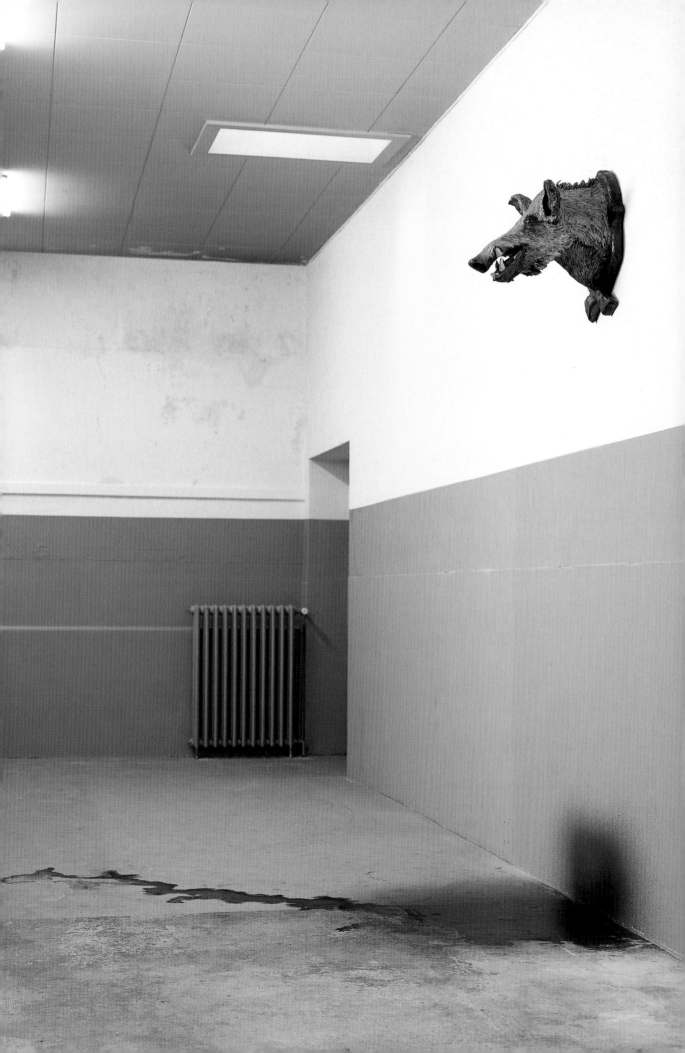

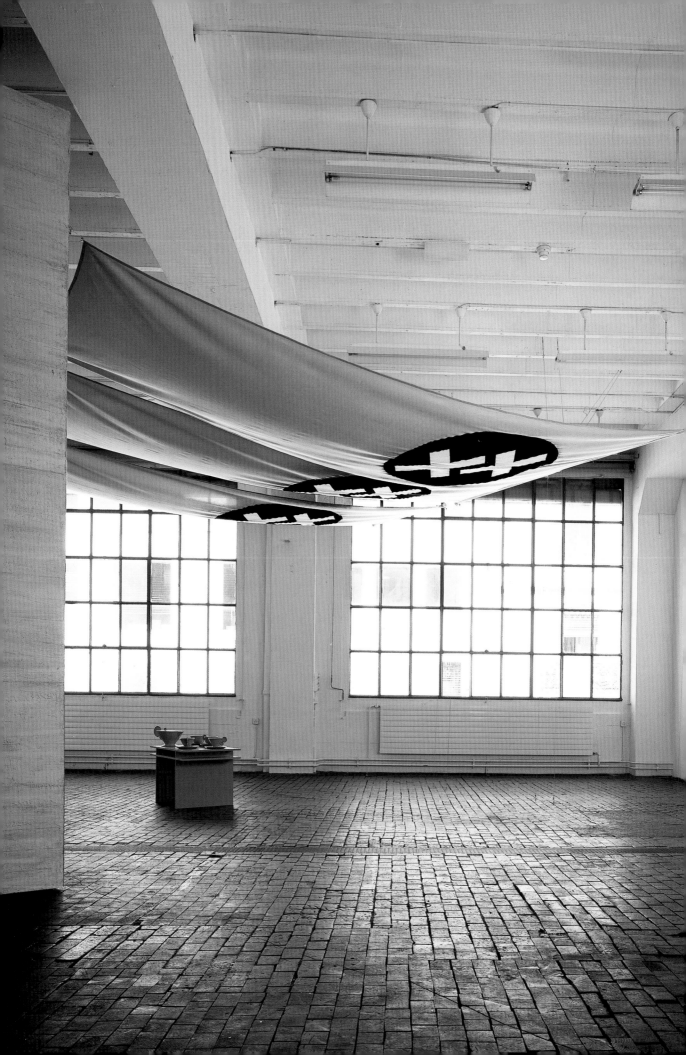

This interview was conducted at two different moments: first, for a publication by Pro Helvetia, in 2003, then for this book, in 2006. The authors have slightly modified the first part of the text for this new publication.

FABRICE STROUN In your work, you create ersatz from Alpine imagery: artificial wine, fake old wood or dry stone walls, etc. Why are you interested in these "traditional" forms? And why do you need to produce copies of it?

VALENTIN CARRON Let's take the example of a piece like *Château Synthèse*, 2000: I was interested in chemically producing a wine from start to finish. A wine with no certificate of origin, with no AOC, that wouldn't carry any regional pride. Valais, the region where I live and work, is supposed to be the incarnation of romantic, natural, and wild Switzerland. A country of tradition. But this tradition was actually completely fabricated at the end of the 19th century, at a time when a political desire to create a national cultural identity emerged. Slowly, people started fabricating pseudo-authentic objects and drawing up rules for the proper design of chalets. In the National Exhibition of 1896, African "savages" were put on display alongside "Schwitzer Hüsli" (little Swiss chalets).

FABRICE STROUN What is your view on this process of cultural fabrication?

VALENTIN CARRON The irony in my work isn't so much about passing judgment on this pseudo-authenticity, but about trying to show what complex negotiations actually go into shaping these things that appear to be natural and self-evident. In a piece like *Authentik*, 2000, authenticity arises from the relationship to a craft-based economy. I took no decision concerning the look of the piece. I simply went to see a blacksmith who makes signs for storefronts and chalets. The word signifies its function because it has been fabricated by an artisan who wanted it to look this way: "authentic." My only real input was to ask him to spell it with a "K," as in the title of the first album by NTM, the famous French hip-hop band of the 1990s.

FABRICE STROUN Why this mix between signs from an everyday rural culture and a specialized urban one, like French hip-hop?

VALENTIN CARRON French hip-hop is actually more of a suburban culture, and the Valais is in way a kind of huge suburb! The area could be best described as a kind of urban periphery. There are no universities, no big industries apart from tourism. It's a long valley with a highway at the center that sends you off towards various small towns, villages, and ski resorts. Each of these zones is like a neighborhood.

FABRICE STROUN Sounds like you're talking about Los Angeles …

VALENTIN CARRON Well, it's true, on a small scale of course! It's true that you can't survive without a car here. Last weekend I started the evening with some friends in a bar in my village, Fully, before going to a party in Sion, the biggest town in the valley. In the morning we drove up for breakfast to Chamonix, a French ski resort, before going down to Aosta, in Italy, to spend the afternoon. We came back to Switzerland through the Grand Saint-Bernard tunnel, to finish ourselves off at the Martigny train station buffet. We do this type of drive all the time. But the fundamental difference with any city, even a totally decentralized one like Los Angeles, or with the French suburbs, is that the Valais produces no indigenous culture apart from its conservative craft tradition.

FABRICE STROUN Do these traditional signs have the same value everywhere? In other words, does a bench carved out of a tree trunk signify the same thing on the main square of a fancy ski resort and on a street corner down in the valley, in your village?

VALENTIN CARRON In both cases it's meant to be reassuring. The real boundary in Switzerland is not language. On the one hand you have the plain, which runs from Geneva to St. Gallen, going through Lausanne, Fribourg, Bern, Basle, and Zurich. This is the urban, industrial Switzerland, the land of business. And then there is everything else, "Heidi Land." This balance is what makes the country. People come from abroad to launder their dirty money in Geneva and Zurich and after that they holiday in some luxury ski resort. These two Switzerlands completely feed off each other. The bestselling postcard in Zurich is a photomontage showing the city with the Alps in the background. Since some sociologists started writing about it, there's nothing hipper for city folks than to go watch a cow fight. Recently I went to visit a friend in the high pastures, and in his fridge he had a milk carton from Coop (a leading national supermarket chain), manufactured god knows where. He has a hundred cows in the barn, yet and my friend drinks the same milk as people in the center of Zurich. It's not so much business Switzerland or authentic Switzerland that interests me, but those power relations that benefit everyone.

FABRICE STROUN But your work isn't simply about economic relations.

VALENTIN CARRON It is primarily a symbolic issue. For as long as anyone can remember, Bischofberger's been on the back cover of *Artforum* with these postcard views of primitive Switzerland, and he's really onto something there. This is primarily an iconography of complete submission to private property, to narrow self-interest, and petty-bourgeois morality and values. The Swiss vision of happiness, what else can I say! In the local tabloids, showbiz and political personalities are always pictured standing in front of a dry stone wall or a pergola. It's just a cheap way of buying themselves an "authentic" local legitimacy. When these signs are used in the Swiss Hotel in Geneva, a place calibrated for Russian and Japanese tourists, they take on the quality of a décor. When they're set up at the center of my village, they appear "natural." But in both cases they're supposed to incarnate the security-obsessed and conservative dimension of national identity, the stultifying and pacified image that the community desires to project.

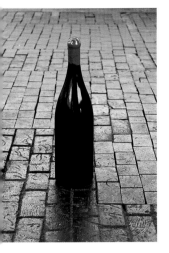

ÂTEAU SYNTHÈSE, 2000

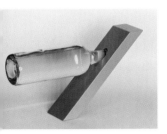

TITLED, 2002

FABRICE STROUN How can your work avoid re-inscribing this dominant ideology?

VALENTIN CARRON It's a complicated question. When I started using this icono-graphy, I felt it was going against a certain type of Zurich art that was fashionable in the 1990s and which was selling a positive, "cool," and almost sexy vision of Switzerland to the outside world. And although I found this image really attractive just like everybody else, it really didn't have anything to do with my everyday experience. So I started turning towards local models of "artistic production" that seemed to counter the dominant aesthetic of the time. When I first thought about carving a bear out of a tree trunk, I originally thought I was going to do it for real. This type of object is not specific to Switzerland. You see them in every forest country. It's a kind of hobby for lumberjacks, it enables them to show that they can do something else with their tools than mechanically cutting down trees. So I went to see some lumberjacks to learn how to use a chainsaw. I was intimidated by the labor it implied. At the same time, nobody out there really sees it as real work, and this activity is only tolerated insofar as it can be recuperated to commercial and, more importantly, ideological ends. Very often these craftsmen, out of some kind of pride, end up giving a piece to their town. These end up on the main square or at the bottom of a ski slope. Very quickly I felt the need to separate myself from this system of exploitation. So I ended up accepting to make "art" after all, adopting a language which, through my choice of materials—resin and fake acrylic wood—comes down from Pop art and produces an immediately visible critical distance. Of course, I'm highly conscious that by reworking such highly conservative tropes within the field of contemporary art I'm also playing some perverse kind of game.

FABRICE STROUN In the sense of contributing to their reification?

VALENTIN CARRON Because I spend my entire days making live-size replicas of the objects I abhor.

FABRICE STROUN As you said, mountain culture is fashionable today. Not only do trendy sociologists write about it, but design magazines like *Wallpaper* put out special issues on the "New Mountain Attitude." Isn't your work also part of this recuperation?

VALENTIN CARRON I sure would hope so! That's actually the main goal. My sculptures are for sale! More seriously, I think the kind of recuperation you're talking about only goes so far, because it primarily operates on the level of nostalgia and glamour. Of all my work, the most reproduced pieces were the *Ski-bobs*, 1999, a type of mountain bicycle fashionable in the 1970s that has totally disappeared today. They weren't very practical, and were principally designed for tourists who didn't know how to ski. In order to find vintage models I placed an ad in the paper. Afterward I went to different tradesmen to get them restored: saddlers, locksmiths, etc. I even called up the Porsche factory that used to build them, so that they would send me drawings of the original hardware. Along the way I removed all the logos and labels, in order to streamline the chromes, to make them more abstract, before displaying them like

Fetish-Finish sculptures. Later, I also called up Roger Moore who lives around here, and took a picture of him riding one of the sculptures. Apart from this particular piece, most of the time I am dealing with objects that come from a social and cultural reality that is way too depressed and claustrophobic to generate this kind of nostalgia. As I told you, there's nothing in the Valais. There are almost no career opportunities whatsoever. It's a primarily working-class population. In school we were all pushed toward technical training. They wanted my friend Balthazar Lovay, an artist who now lives in Geneva, to become a window-blind installer ... Finally we managed to get into the art school in Sion. Most of the young people only dream about leaving. And if they do come back, even if they've acquired a much better economic situation than if they had stayed, they see it as a failure. Most of them can never connect with the local population again. When they need to get a picture taken to demonstrate their social position within the community, they'll pick the pergola or the dry stone wall again, to buy back some kind of lost identity. But to close off the topic of "recuperation": I once was invited to a "favela chic" party in the Paris art world ... So there's still some hope!

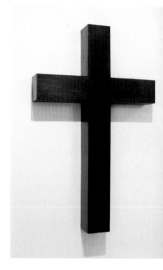

FOSBURY FLOP, 2006

FABRICE STROUN Can you give me an example of an object that the artworld still has a hard time recuperating.

VALENTIN CARRON Frankly, I was surprised to see how violently people reacted to the Christian cross in fake concrete and cinderblocks I recently showed at the Basel Art Fair. After all it was built using classic minimal proportions ...

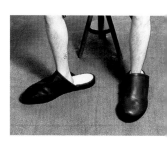

UNTITLED (TRIBUTE TO ROBERT WADLOW),
2000

FABRICE STROUN Right now you're working on pieces for Paris and Vienna that use Nazi symbolism ...

VALENTIN CARRON The piece for Paris will be called *No Logo*, in reference to the Naomi Klein book I just finished reading. It's a hanger with five identical jackets that have a little red embroidered swastika hidden under the armpit.

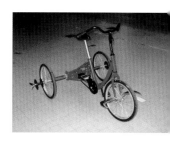

DEATH RACE 2000, 2000

FABRICE STROUN Does the piece refer to the ambiguous role Switzerland played during the Second World War?

VALENTIN CARRON No, not directly. It's not about the current rise of neo-Nazi movements either. Here hatred of the other is expressed in much more mundane and sly ways. Here's a little anecdote: last year I was working for a real estate agent. Before purchasing an apartment, clients go through the names on the letterboxes to see how many foreigners live in the building. Nobody ever talks about it openly, but everybody knows about it. In fact, beyond a certain ratio, the value of the building goes down. For this piece I used the kind of jacket that office clerks or people working at smaller levels of state administration usually wear. I removed every single label, all the signs that might reveal their original make, before re-branding them. I felt the armpit was the least obvious place for a logo. You could wear the jacket normally, and nobody would notice anything. It's only revealed through the gesture ...

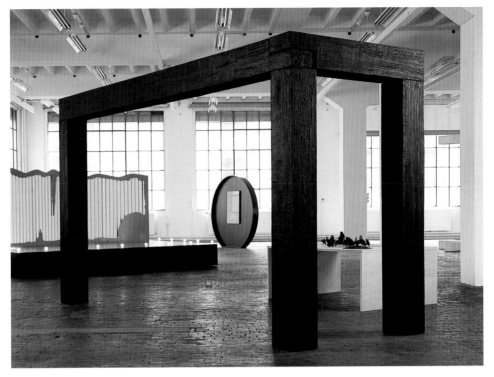

Installation view: *Mai-Thu Perret versus Valentin Carron. Solid Objects*
Centre d'art contemporain, Geneva, 2005 [UNTITLED (PAVILION), 2003]

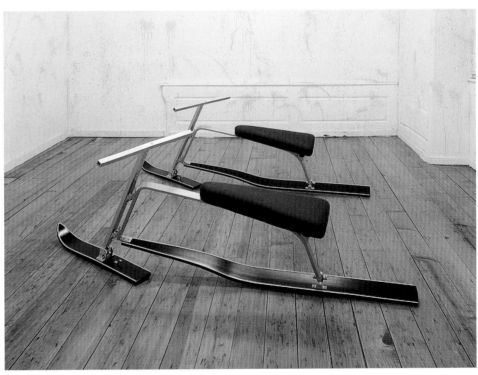

Installation view: *Turbo*
CAN, Neuchâtel, 2000 [TURBO, 2000]

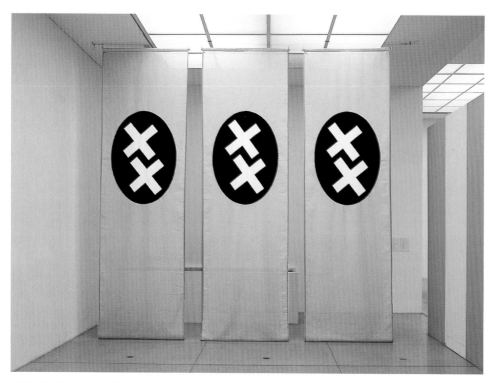

Installation view: *Kontext, Form, Troja*
Secession, Vienna, 2003 [ORIFLAMMES, 2003]

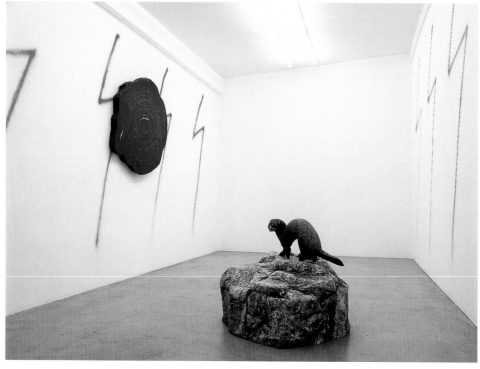

Installation view: *Fer de Lance*
Galerie Francesca Pia, Bern, 2005 [PUZZOLA, 2004]

FABRICE STROUN I'd like to go back to pieces such as *No Logo* or *Oriflammes*, 2003, three banners using the symbol referencing a Nazi swastika imagined by Hollywood decorators for Charlie Chaplin's *The Great Dictator*, 1940. Last year you showed a wall painting entitled *Zorro*, 2005, at the Galerie Francesca Pia in Bern, which covered all the walls of the gallery with an S-shaped lightning bolt, as in the "SS" sign.

VALENTIN CARRON *Oriflammes* is a faithful copy. Although color bonuses have recently been released for movies fans, the original film was shot in black and white, hence I executed the piece in grayscale, which heightens the ghostly and slightly unreal quality of the object.

FABRICE STROUN This piece was produced for an exhibition at the Secession, in Vienna. Wasn't there some intent to provoke on your part?

VALENTIN CARRON No, not really ... although, yes, maybe a little, but not more than that ... At Francesca Pia's, the abovementioned wall painting was part of a bigger installation, entitled *Fer de lance*, the centerpiece of which was a skunk perched on top of a rock, emitting a recording of Ravel's *Boléro*, which I had asked a musician to replay on a xylophone.

FABRICE STROUN Why Ravel's *Boléro*? What does all this have to do with the "SS" sign?

VALENTIN CARRON The skunk originally incorporated a smoke machine and was intended to spew out dry ice through its anus, but I had some technical problems and so, at the last minute, I replaced the smoke machine with a CD player. The *Boléro* is a cliché, possibly the first example of what would latter be called "world music," an immensely popular tune which in many ways is as vulgar as a skunk, or the special effects in a little provincial nightclub. There's no value judgment in what I'm saying, I'm actually extremely fond of those kind of places. This is where the painting came from, like a musical score, a G key, a motif scanning the entire space with a kind of rhythm. At the time, this font felt like the most brutal I could find, a way for me to try out the worst, not as a fantasy or a regression, but in a naturalistic manner. I used a spray can to make something like those tags you find in cities all over Europe. Its displacement in an art context only removes about 1% of its "awfulness," and yet it seems to be enough. The same "S" on a synagogue would be real trouble, but suddenly here, as a sequence, in a gallery, it becomes almost acceptable, at least enough to be exhibited and sold ... The title (*Zorro*) softens the blow as if by miracle, it turns everything into a big stupid joke. And yet the displacement I make is really slight, not enough to be any kind of "critical" recuperation. In the end this piece was not simply a technical failure. There were real problems at the level of its reception. Maybe it's better this way ...

FABRICE STROUN Why do you say that?

VALENTIN CARRON I think that the iconography somewhat covered up my intentions. This painting plays on a register that is infinitely more pathetic than "critical." I was thinking about all the drunken kids bored on the

weekend with a spray can within reach, but also about the kind of geometric wall paintings made by some of my friends. I've actually recently remade some crosses, as wall sculptures this time. It's a sign which used to be as profoundly inimical to certain Left-wing thinking as the swastika; for a long time they saw anticlericalism and antifascism as two sides of the same coin. In the end these religious signs are today much more ambiguous than those of German National-Socialism.

FABRICE STROUN I'd like to talk about the issue of the cultural reception of your work. You work with a regional iconography that is instantly legible in Switzerland. What happens when your works travel beyond our borders?

VALENTIN CARRON Nothing is more global than local issues …

FABRICE STROUN In general I'd tend to agree with you, but I think that some subtle points of your work might pass unnoticed outside of a specifically Alpine cultural context. Taking as a counter example the work of an artist with whom you have exhibited before, Gardar Eide Einarsson, a Norwegian artist living in the US, one could say that his pieces have as much to do with a "local" culture (Scandinavian Death Metal, for example) as with a global one related to American social and political history, and therefore familiar to everyone in the West. Hence it would seem that his works are potentially legible, in all their finer points, by a much larger audience than yours.

VALENTIN CARRON After spending nine months in Paris (for an artists' residency), I made an exhibition for the Eva Presenhuber gallery in Zurich, in which I showed an alignment of cannons in the main room. The model for these works came from the Invalides in Paris. Don't ask me why, but I ended up going to the Invalides every three days. In some sense I did a classical exhibition of contemporary minimal art in this room, as a distant homage to the art of the 1960s. It was geometric, serial, elegant, and played simultaneously on two types of institutional conventions, those of the exhibition of historical objects and those of the avant-garde. The fact that the provenance of these objects was French, that they came from the museum of the Invalides, had little actual relevance. Everybody got it. It was about the centralization of power, the violence intrinsic to these kinds of symbols, and the fact that we were in Zurich, a financial center, was also heightened … Actually I don't think American history is as transparent and self-evident as you say. Gardar, even in the US, always provides critical texts to accompany his shows, he inscribes his works in a "narrative." I won't do this; my works have the ambition (maybe it's naive) to exist in themselves, as autonomous objects. What we are discussing in this interview are my personal recipes, and as far as this is concerned, I have no desire right now to try to fit in somewhere else. First, I don't feel entitled to speak about cultural particularities which I don't share, and second and most importantly, I'm far from having exhausted my fascination (in many cases it has been going on for years) with artifacts scattered in a ten mile radius around my home.

FABRICE STROUN What do you mean by "autonomous"? You always discuss your fascination for these objects in terms that are culturally and historically

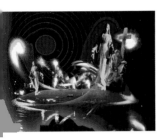

CK IN THE DAYS, 2005

UD, 2005

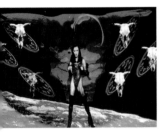

GINE SWING, 2005

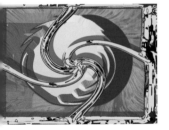

DE, 2005

ELUDE, 2005

E BOOGIE, 2005

determined. Although I'm ready to believe that this context does not function as a unifying "narrative" for you, it nevertheless provides a context for the reading of your work.

VALENTIN CARRON In Zurich, in the second room, I rather haphazardly piled up a dozen works, as a reserve of ideas containing everything I'm potentially capable of. One of these pieces was called *Lasciatemi vivere la mia vita*. The model for the piece, which I again reproduced at a one to one scale, is kept at the Gianadda Foundation in Martigny, an extraordinary place which has attracted about seven million visitors since it first opened in 1980 (that's 270 000 visitors a year, in a town of 15 000 people) thanks to its exhibitions of classical modern art, its automobile museum, and its museum of Gallo-Roman artifacts! The original sculpture is a metal skeleton representing a soldier, set on a 80 cm high pedestal, on which have been grafted an arm and a leg from a Roman statue whose remains were found a few miles from the city. For the base they used stone from the Gard, in the South of France, to get a more authentic feel. As for the skeleton, it was commissioned from a local neo-modernist sculptor. It's a completely incongruous and bastardized object; I attached a title from a Mike Brandt song ("Laissez moi vivre ma vie"), translated from the French and meaning "Let me live my life!" to my replica of it.

FABRICE STROUN And who is Mike Brandt?

VALENTIN CARRON He was an Israeli Pop singer, discovered in a Tel Aviv nightclub by the variety singers Dalida and Carlos in the 1970s. Apparently he was a charming and beautiful guy, and they brought him to France. He didn't know a single word of French and they dressed him up like an American and made him sing songs in French that sounded like Italian variety. He ended up killing himself. It's a rather sad story. His song "Let me live my life!" is something I could also imagine myself humming. Or it's the statue that could be bellowing it, as a kind of "fuck you" to the alleged autonomy of modernist sculpture. Only by corrupting the program can some kind of freedom be found, as in this Hollywood movie I just saw: "perfect" robots, also intended to be "autonomous," are programmed to work as our slaves, but it is only through the discovery of their own heterogeneous and corrupted nature that they acquire their true autonomy; they end up leaving to live their own life and, finally, leaving us in peace …

UNTITLED, 2002
→

UNTITLED, 2002
→ →

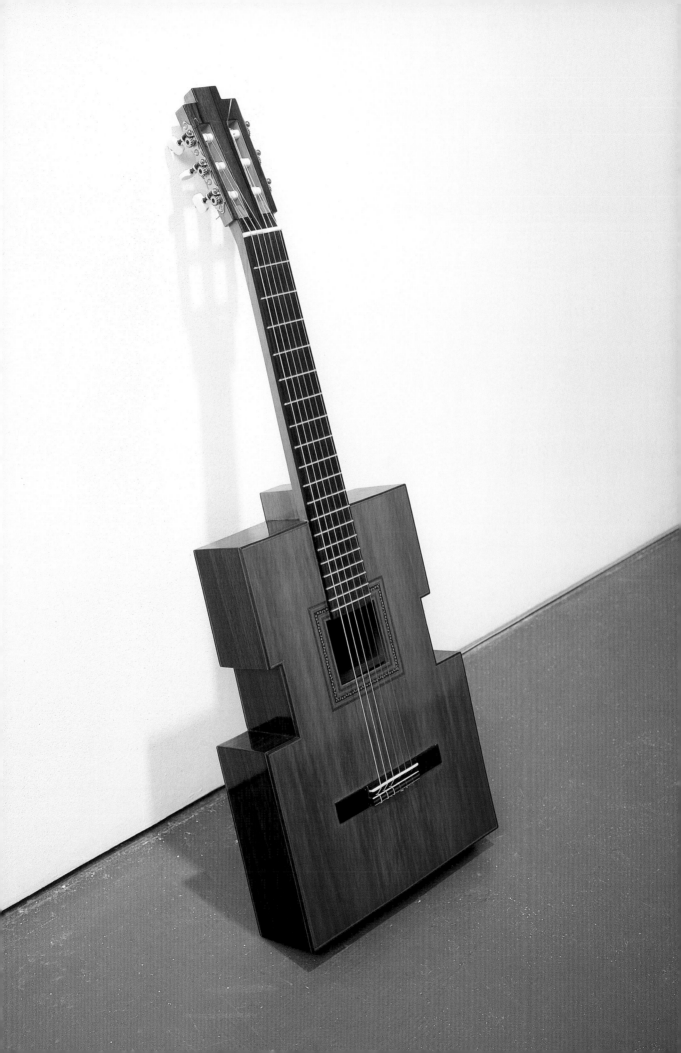

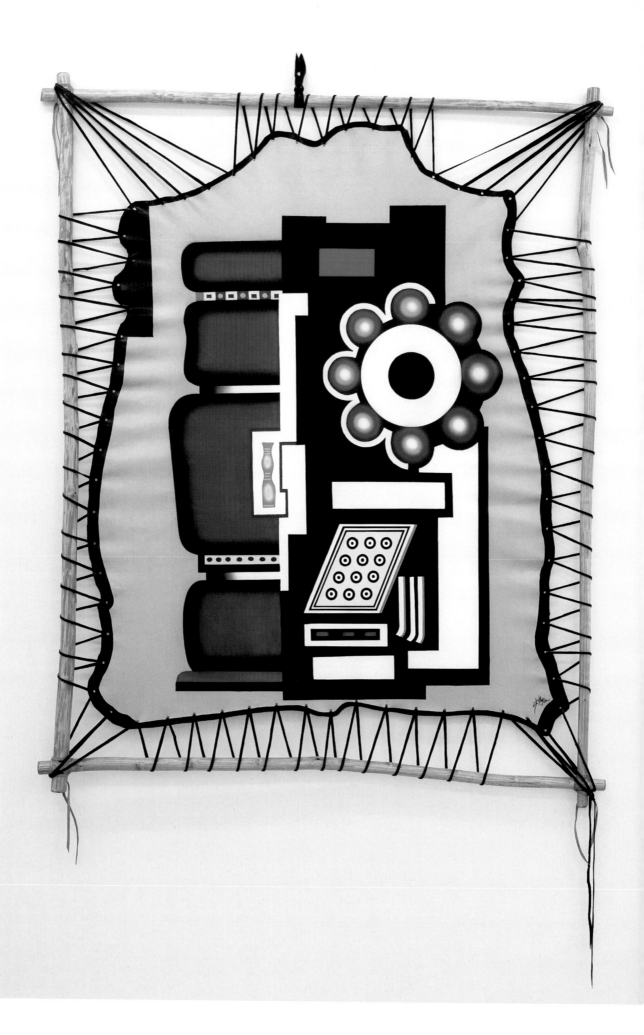

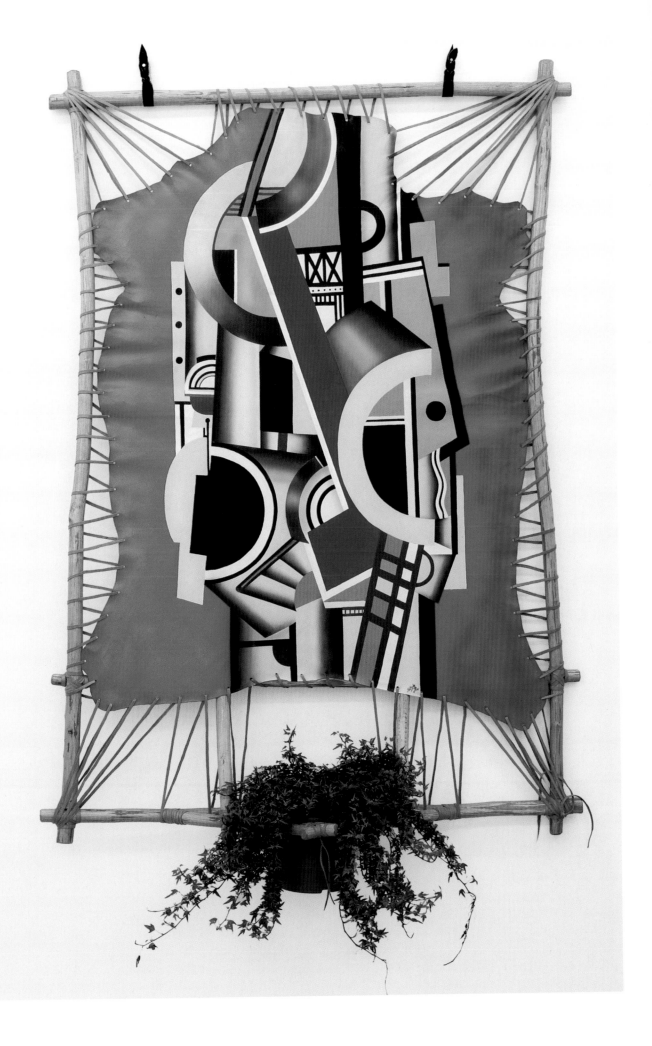

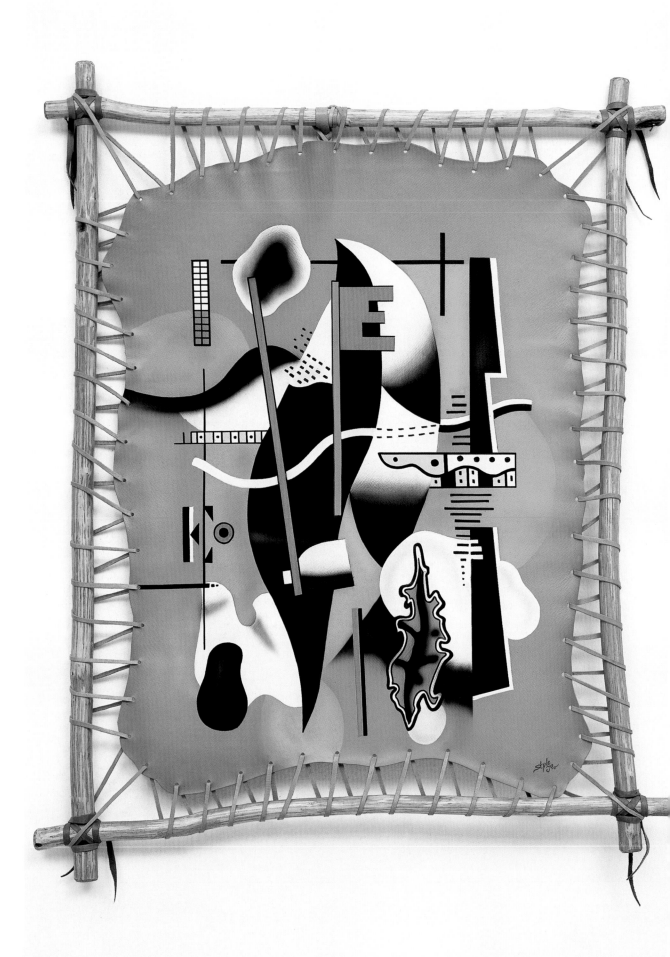

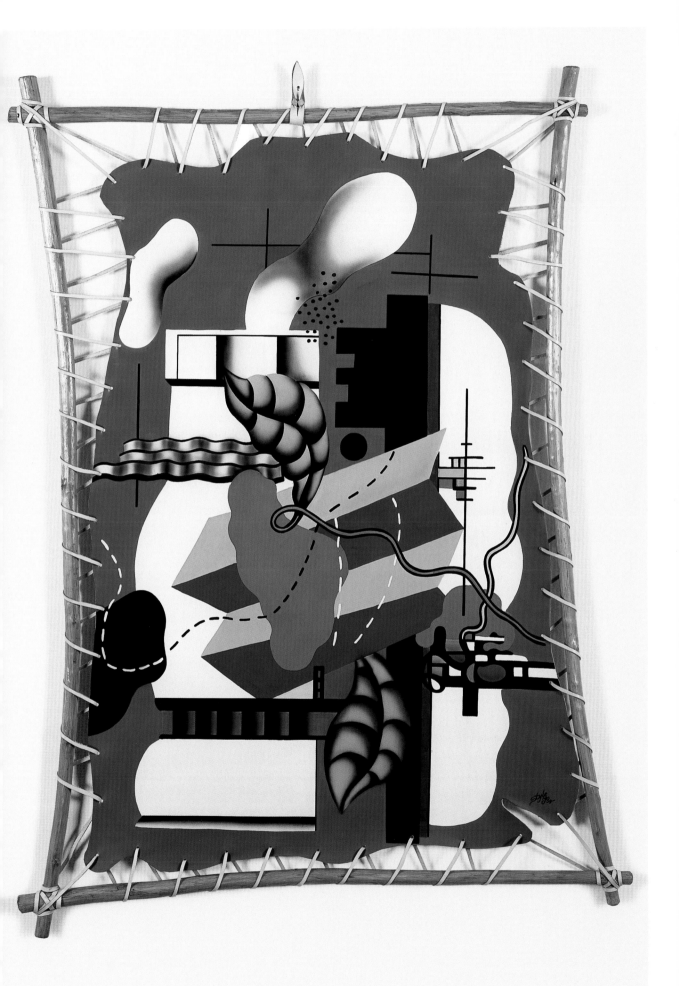

UNTITLED, 2004
←

UNTITLED (STILL LIFE WITH KEY), 2005
← ←

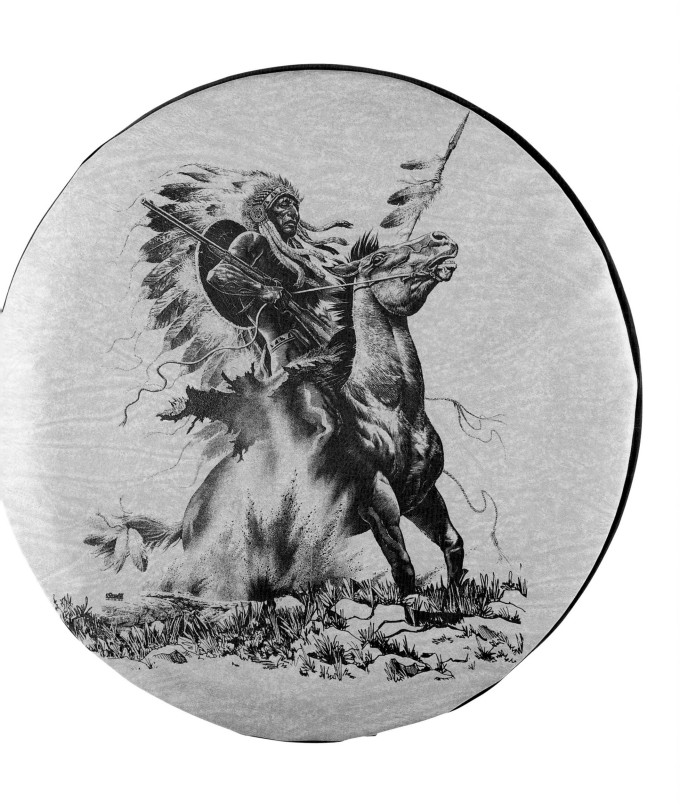

41

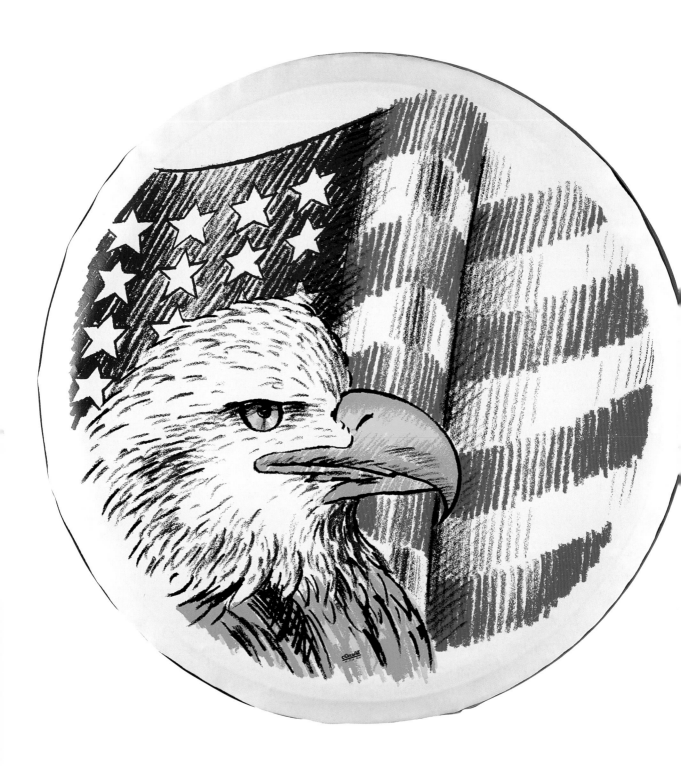

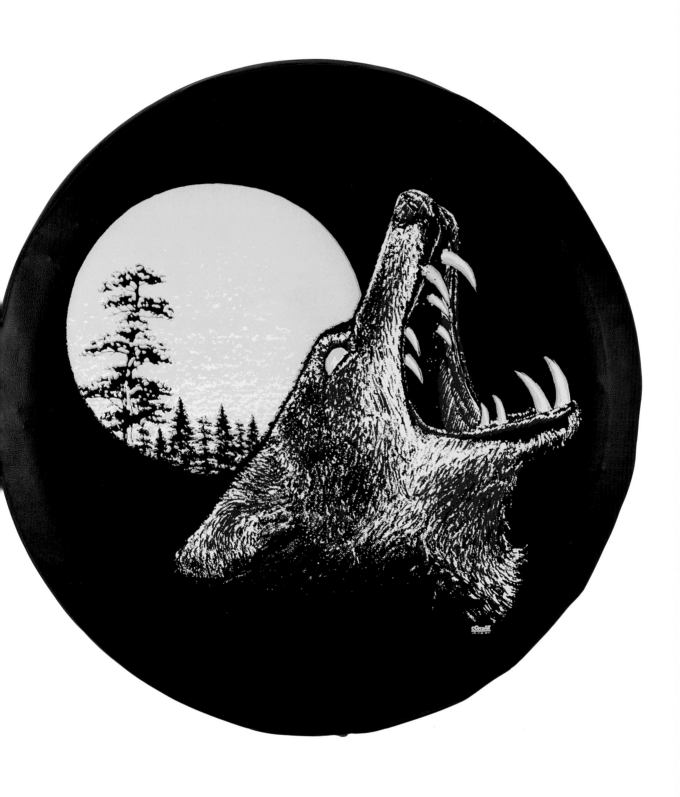

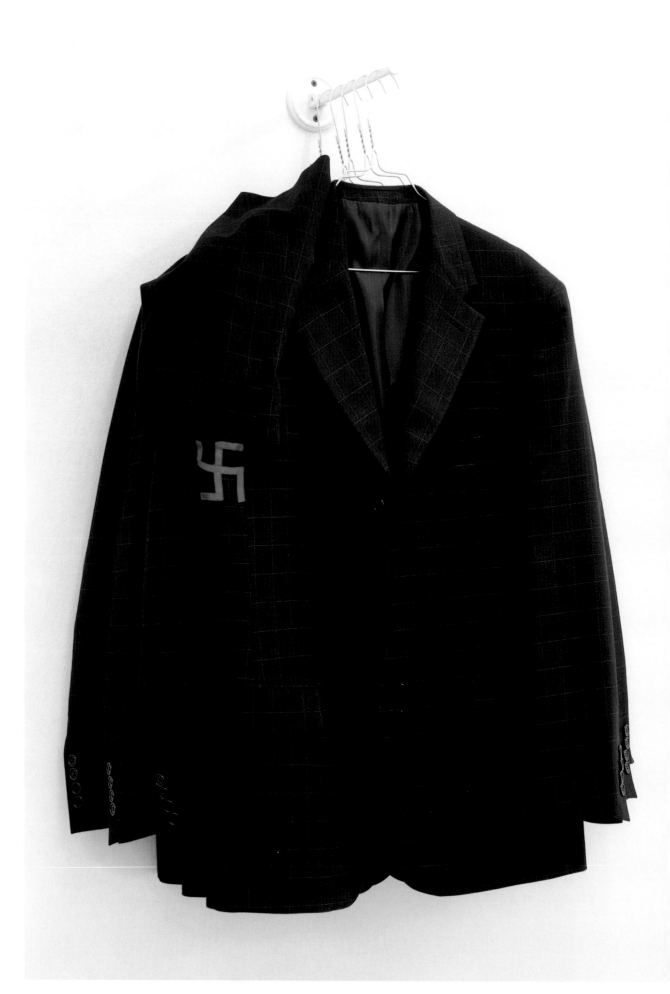

from Michael Bracewell and Orson Welles

Harry Lime: "Don't be so gloomy. After all it's not that awful. Like the fellow says, in Italy for thirty years under the Borgias they had warfare, terror, murder, and bloodshed, but they produced Michelangelo, Leonardo da Vinci, and the Renaissance. In Switzerland they had brotherly love—they had 500 years of democracy and peace, and what did that produce? The cuckoo clock. So long Holly."
—*The Third Man*, screenplay by Graham Greene, 1949

Explosions of paint on pristine gallery walls; carved mountain animals; "Ski-bobs"; a tricycle with blades attached to its wheels; a man's suit jacket with a scarlet swastika concealed under one armpit; some designs that appear to be in the style Fernand Léger; a huge model of an axe embedded in a tree stump; some cartoon Alpine scenery; some spooky looking transparent tubes attached to some kind of tank; more explosions of paint; some cheerful letters spelling out an angry "GRRR."

To someone coming to Carron's work with no prior expectations, and no personal agenda on what they would like his work to achieve, there is the immediate sense that here is an artist doing three specific things. Firstly, he is playing with notions of national identity—or to be more precise, he is turning unconsidered perceptions of the Swiss Alpine landscape into a violent cartoon. Secondly, within this translation there is no small amount of exasperation, astute historical awareness and a touch of genuine anger (" ... I spend my entire days making life-size replicas of the objects I abhor ... " Carron has said to Fabrice Stroun). And thirdly, within the considerable breadth of media that Carron employs, he is rounding up the movements of modern Western art since Duchamp, and in a way which is at once curatorial, postmodern and healthily satirical.

Looking at the work of Carron without trying to weigh it down with any cultural historical baggage—rather like listening to a record solely as a piece of music, as opposed to a signifier within an evolved lineage— you feel to be experiencing a deeply felt, teasingly assured and potentially volatile expression of a particular landscape, and the temperament pertaining to that landscape. The impact of the different pieces, in all of their different media (although there are many common denominators of sensibility between them) lies in the tension they embody between moderate, genteel, affluent respectability, and violent, heretical, self-scrutiny. In short, this is an art which seems to pay homage to the traditions of a culture, while simultaneously usurping and re-positioning their values.

In one way, I am reminded of the art of David Shrigley—there is a similar deftness to the way in which the works declare themselves, almost as sentient presences, but representative of a crazed intensity. In another, I could think of Carron's art as being a curious, slightly disturbed offspring, created by a union between Duchamp's belief in the necessity

of art's "hilarity" and the postmodern appropriations of American Pop art by Jeff Koons or Mike Kelley.

In terms of feelings, however (and Carron, like Gilbert & George, might well be an artist who is more concerned with feelings than ideas) it seems to me that Carron is interested in temper—which is another quality his art might share with that of David Shrigley. In interviews, Carron has often been asked about his home in Valais, and about the relationship of his work to the way in which Switzerland has been perceived by tourists no less than cultural commentators.

If Switzerland is at times perceived (with or without justification) as a kind of eternally pure, European California—a glorious, pre-Lapsarian fusion of wealth, peace, prosperity, health and breath-taking scenery—then Carron is attempting to describe what might be Switzerland's "shadow" or reverse—the dark or skewed side of all that comfort, tradition and prosperity.* Such a role as Carron's, however, is more exposed and responsible than becoming an exquisite court jester to an audience of the culturally sophisticated. In the art of Valentin Carron there is an edge of genuine anxiety—it could perhaps be described as the artistic equivalent of imminent claustrophobia. His works make use of humour, shock, surprise, irreverence; but it does not seem as though they are happy or able to simply luxuriate, with Swiss ease, in the warmth of their undoubted effect.

Rather, the art of Carron seems to forge a link between a distinctly European sensiblity and the darkly ambiguous neurosis of much contemporary American culture—not least America's contorted relationship with the iconography of its own landscape, as a sacrificial wilderness, alternately feared and enshrined. In his working relationship with the indiginous culture in which he has grown up—with its traditions, craftspeople, regional specialities—Carron seems less concerned with debasing or destroying those values and attainments, and more interested in their mirroring qualities.

In the modern age of a luxury consumer mono-environment, what passes for a "real" culture anyway? And what emotional investment do we maintain in authenticity? Beginning his replies with a certain necessary violence, Carron opens up these questions, and offers a response to Harry Lime's cuckoo clock.

* On a recent trip to Geneva, I saw only two policemen during my three day stay in the centre of the city. They were admiring a Ferrari.

My mother, who spent her whole life waiting for me to get a serious job, used to love bears. Now, one of Valentin Carron's emblematic works is a sculpture of a bear that looks as though it has been carved out of a tree trunk. But is that really what it is and who exactly did what? We are told that Valentin Carron systematically delegates the actual making of his pieces to skilled craftsmen; and that his works play on simultaneous levels of reality, sometimes using false wood, sometimes false marble, to give the sculptures the appearance of being at once the "real thing" and "anything but it." I might as well make myself clear from the outset: I am not interested in these problems of fake, imitation, or authenticity. Like Ryman, I think that what counts is not what you do, but *how* you do it. And, I hasten to add, *who* does it.

I asked myself these questions way back, at a time when my two colleagues Toroni and Buren had launched out in producing works made by others. Of course, anyone could do what we were doing, but you still had to *do it* … And the whole point is that a Buren made by Toroni is not really a Buren. Painting (or the bear) transcends its technique: the presence of the object (or the animal, as with Jeff Koons' puppy for instance) is powerful enough for technique to take a back seat and the rhetoric of the materials to fade away. The artist himself is just one variable in this process—what remains is art or, here, the bear. And, while in Duchamp's famous equation it is indeed the spectator who makes a place for the picture within the art system, nonetheless it is the maker who produces the picture—unless it produces itself.

I obviously have a liking for Valentin Carron's "abstract" sculptures and I like his use of "paintball" for wall painting. The fact that his position may be seen to contradict those of a young (French-speaking) Swiss scene with which I feel some affinity in no way lessens my appreciation of a monumental cross in white roughcast, or an unlikely space from which the *Partisans Song* played on church bells seems to be coming. Because ultimately aesthetic decisions are not the privilege of the artistic field: what Valentin Carron's work shows is that there is such a thing as a *formalism of everyday life*, an inner need to be constantly making aesthetic decisions, whether it is picking an iridescent color for the car, repainting the bathroom, or choosing a tie.

In this sense, if the way that Valentin Carron looks on whatever craft production interests him results from a particular historical possibility (the designation of readymade objects), the artistic approach behind this personal view (its "re-constructive" capacity, vernacular aspect, or technical specialization) is something all his own. It is what he does, and this style of his is a part of the story.

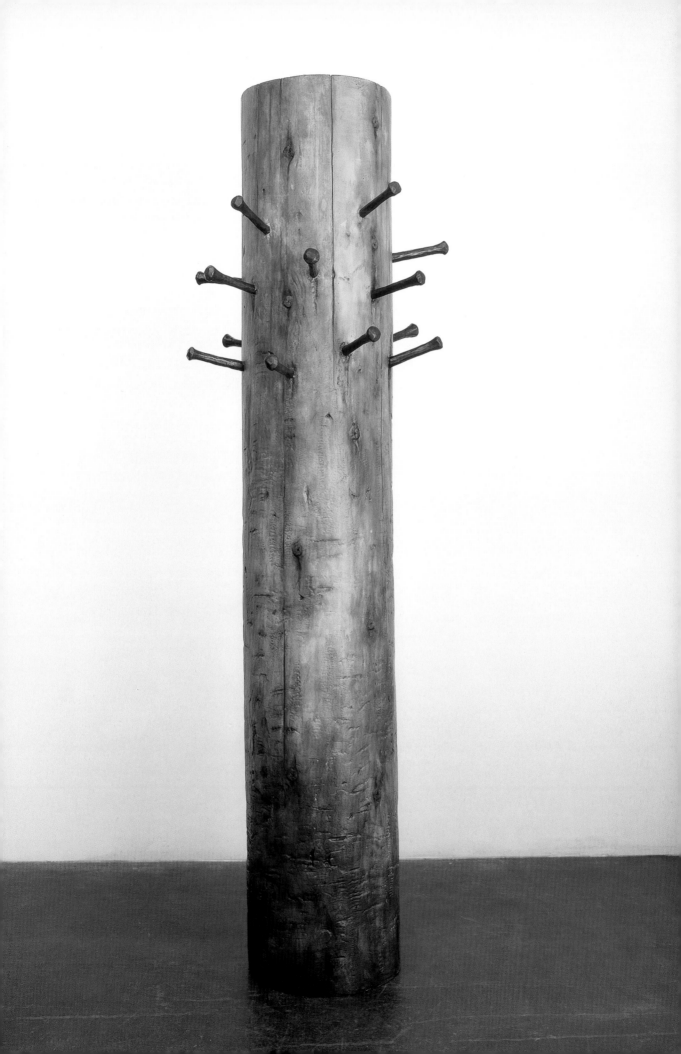

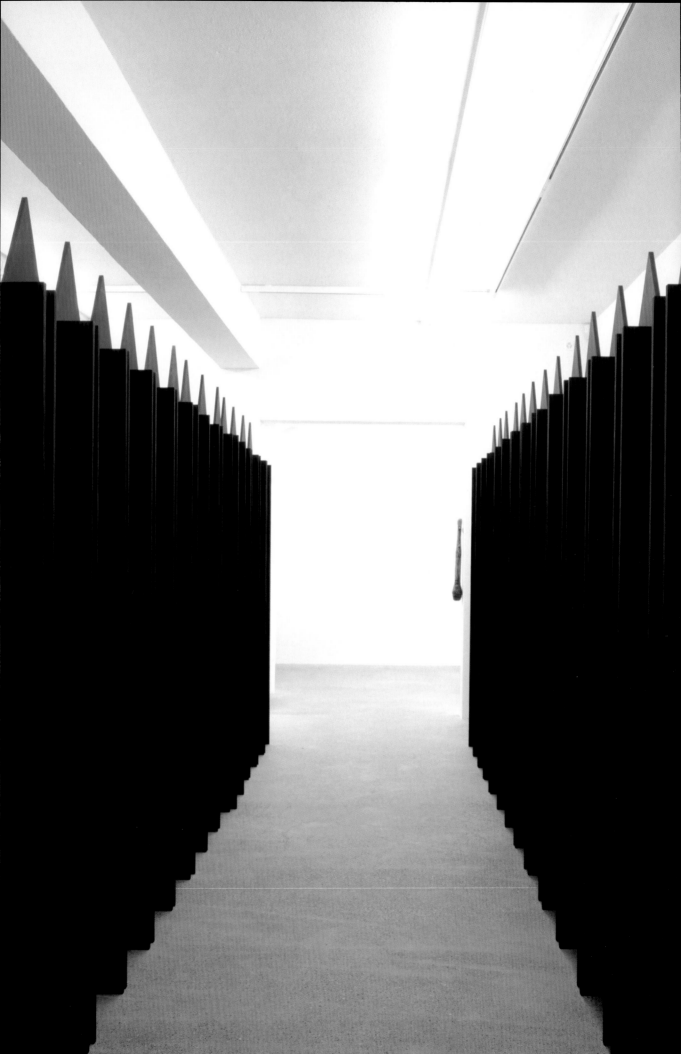

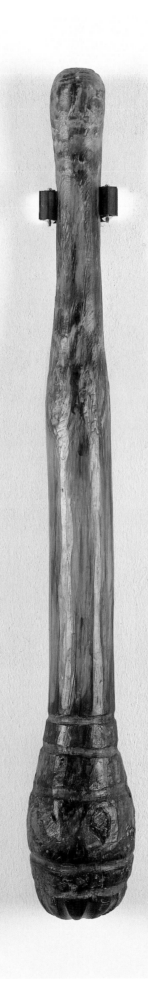

RANCE CLUB, 2005
← ←

TO BE FRUIT, 2005
←

RANCE CLUB, 2005
← ←

L'HOSTILE, 2005

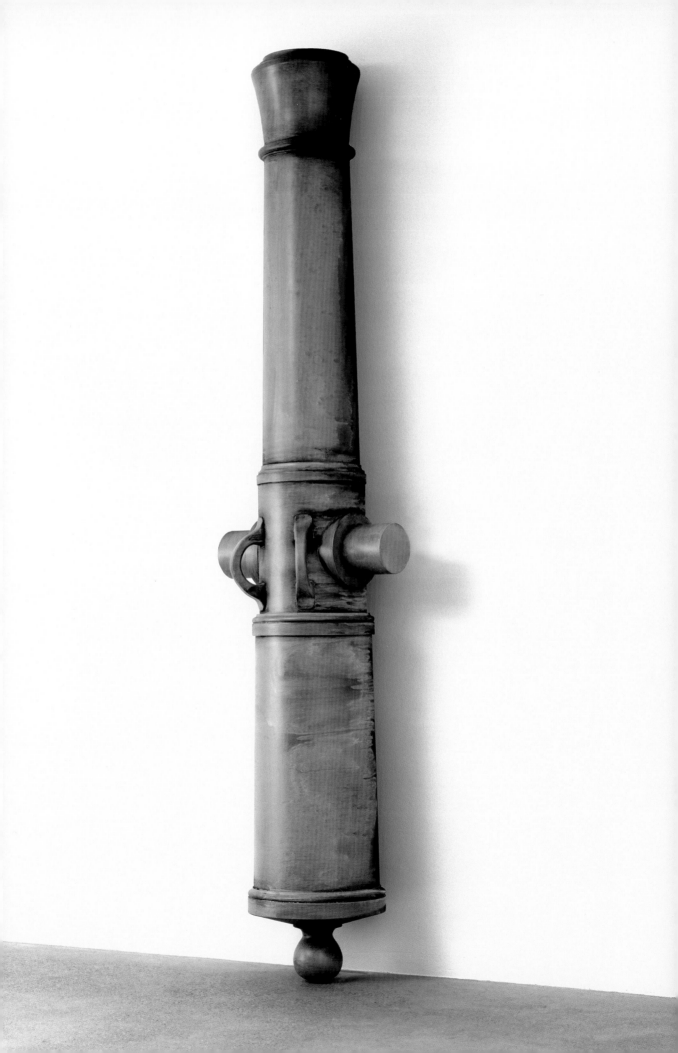

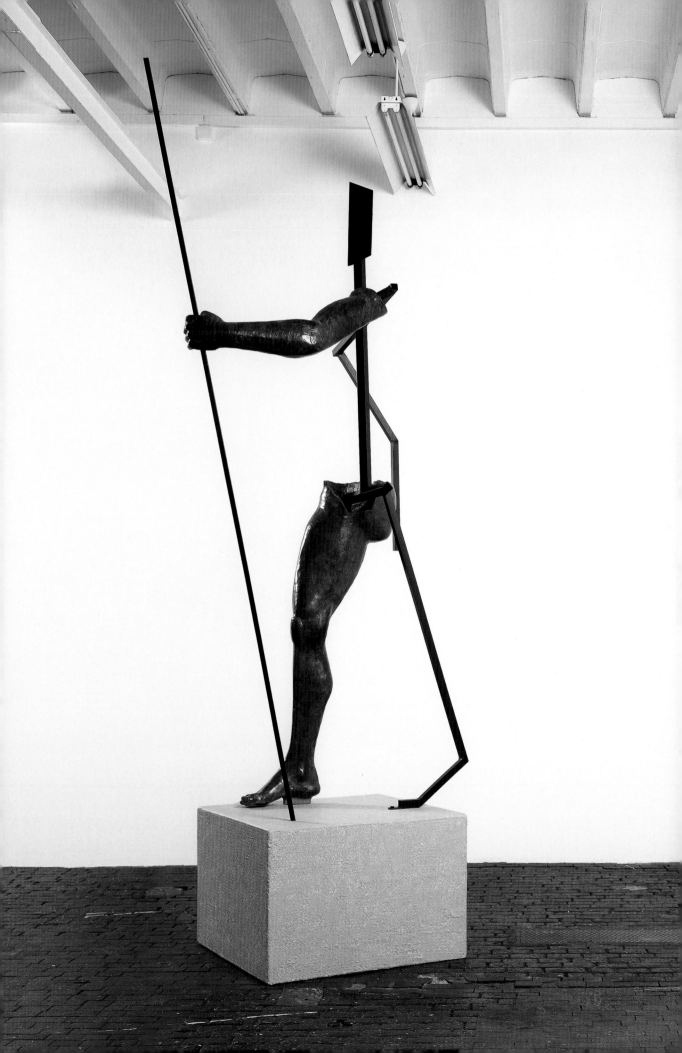

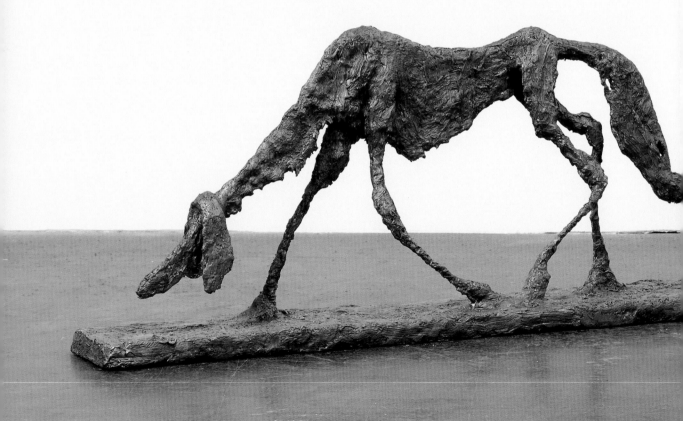

CHIENS, 2006

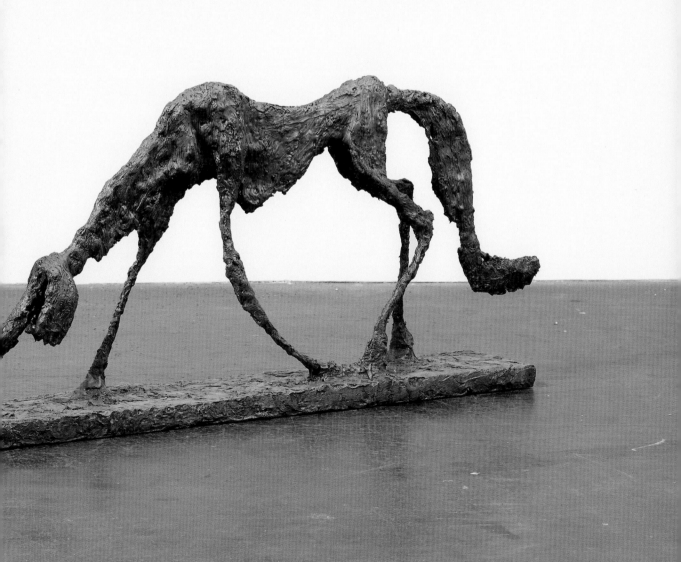

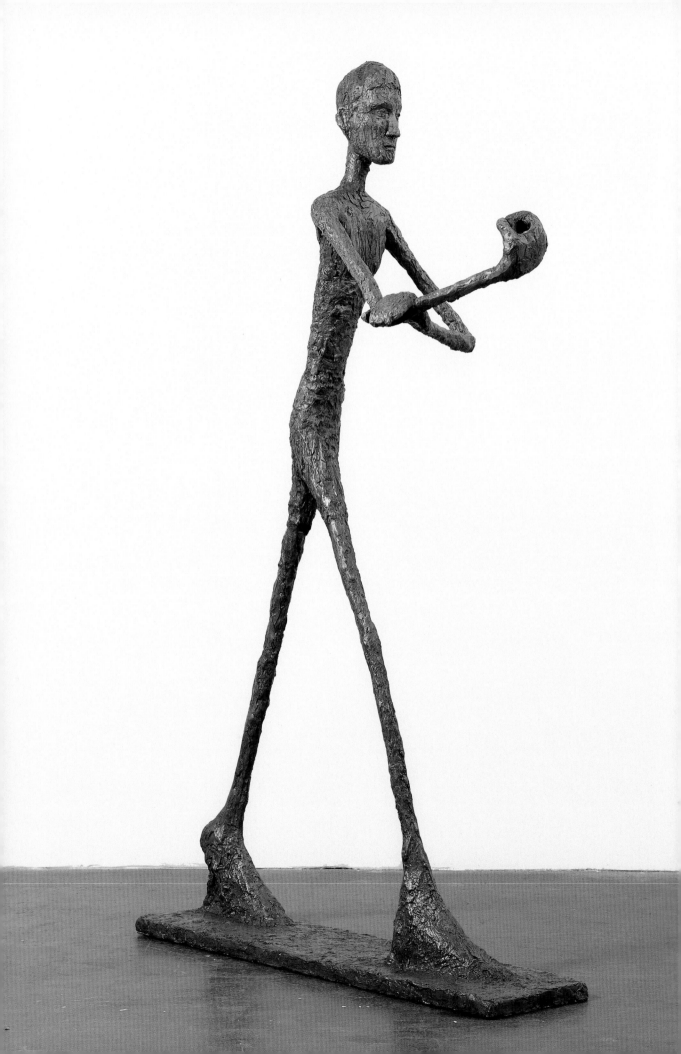

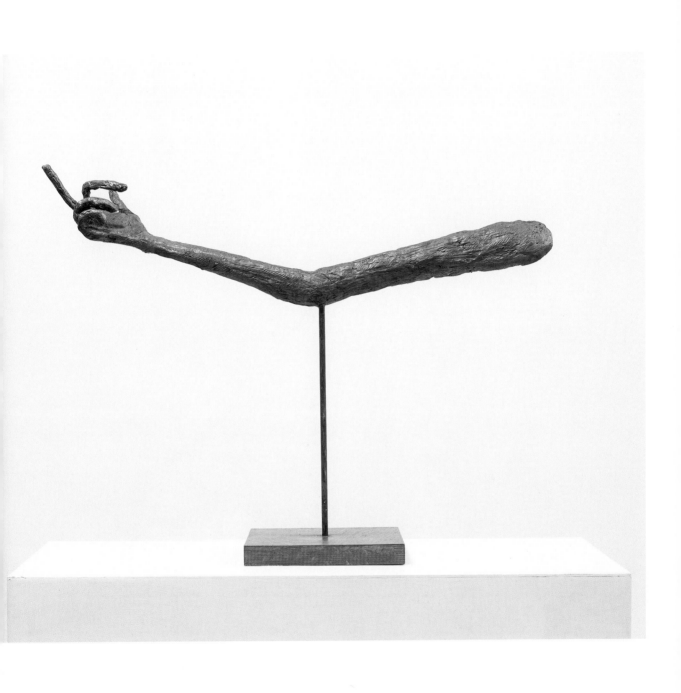

L'HOMME, 2006

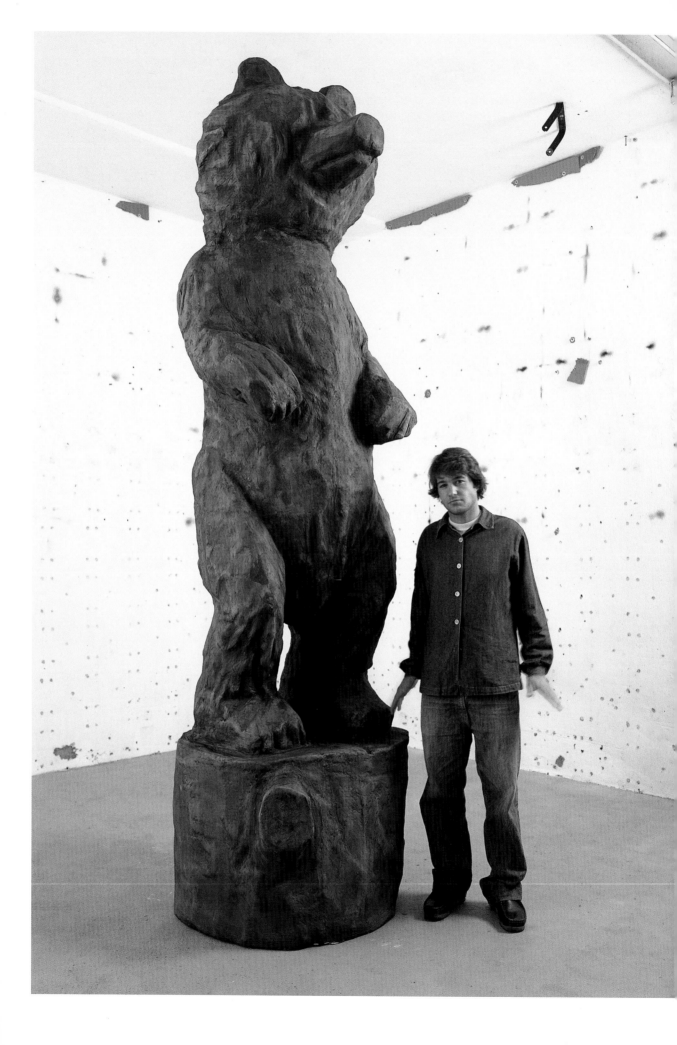

Born in Martigny, Switzerland, 1977
Lives and works in Fully (VS, Switzerland)

AWARDS
2001
 Prix Möet Hennessy
 Swiss Art Awards
2000
 Swiss Art Awards
1999
 Prix Odette Steinmann
 Prix de la Fondation Ernest Manganel
 Prix d'encouragement à la création de l'Etat du Valais

SOLO EXHIBITIONS
2007
 Kunsthalle Zürich, Zurich
2006
 Déchéance, élégance, déhanchement, Swiss Institute,
 New York
 Valentin Carron versus Mai-Thu Perret. Solid Objects,
 Chisenhale Gallery, London
2005
 Rellik, Galerie Eva Presenhuber, Zurich
 Mai-Thu Perret versus Valentin Carron. Solid Objects,
 Centre d'art contemporain, Geneva
 A crédit et en stéréo, Galerie Francesca Pia, Bern
 Hip, Hip, You're Raw, Alimentation Générale, Art
 Contemporain Nosbaum & Reding, Luxembourg
 Fer de Lance, Galerie Francesca Pia, Bern
2004
 Le mal nécessaire, Charles-François Duplain, Porrentruy
 Art Statements, Art Basel 35, Basle
 Land Crusade, Galerie Evergreene, Geneva
2003
 Galerie Praz-Delavallade, Paris
 Freelander, Alimentation Générale, Luxembourg
2002
 Sweet Revolution, Fri-Art, Fribourg
 Jeep heep heep, Galerie Francesca Pia, Bern
 Land over, FAC, Sierre
 After the hunting rush, Circuit, Lausanne
 Galerie Kamm, Berlin
2001
 La conduite du Rucher, Mamco, Geneva
 Easy glissing, Glassbox, Paris
2000
 Turbo, Le studio/CAN, Neuchâtel
 Saison Morte, Forde, Geneva
 Slide Side, Camion, Sierre

GROUP EXHIBITIONS (SELECTION)
2006
 In den Alpen, Kunsthaus Zürich, Zurich
2005
 Ok/Okay, Swiss Institute, Grey Art Gallery, New York
 *We really have to strain ourselves to still discover
 mysteries on street signs*, Centre for Contemporary
 Art, Warsaw
 Enchanté Château, Château d'Arenthon, Fondation
 Salomon, Alex (France)
2004
 It's All an Illusion, Migros Museum, Zurich
 Dalla Gina Allo Spazio, Lugano
 Homo Social, Champion Fine Arts, New York
 Genesis Sculpture, Domaine Pommery, Reims
 Fürchte Dich, Helmhaus, Zurich
 La piste noire, Galerie Loevenbruck, Paris
2003
 1st Prague Biennale
 Kontext, Form, Troja, Secession, Vienna
 Fink Forward, Kunsthaus Glarus
 In diesen Zeiten, c'est le moment, Centre PasquArt,
 Bienne
 Mursollaici, Centre Culturel Suisse, Paris
2002
 Energies de résistance, attitudes, Geneva
 The golden week, Kodama, Osaka
2001
 Camo-Show, Kunsthaus, Wiesbaden
 Synthétiseur, Espace Fauriel, Saint-Etienne
 Vraissemblablement, Alimentation Générale, Luxembourg
 rock paper scissors, Galerie Francesca Pia, Bern
2000
 Prix fédéraux des Beaux-Arts 2000, Fri-Art, Fribourg
 La station fait main basse, Galerie des Ponchettes, Nice
1999
 Canapé, l'elac, Lausanne
1998
 Maison de Courten, Sierre
 Gorgeous, l'elac, Lausanne

BIBLIOGRAPHY (SELECTION)
2006
 Pierre Keller, "Valentin Carron," *Bilan*, Lausanne,
 no. 200, March 15–28, p. 63
 Eva Scharrer, "Valentin Carron. Galerie Eva
 Presenhuber," *Artforum*, New York, no. 7, March,
 p.307
 Catherine Hug, "Valentin Carron," *Tema Celeste*, Milan,
 no. 113, January–February, p. 62–67
2005
 Daniel Baumann, "Valentin Carron: Rellik," *Spike*,
 Vienna, no. 6, Winter, p. 107–108
 Nicolas Trembley, "Souvenirs de Suisse," *Numéro*, Paris,
 no. 66, September, p. 82
 Marguerite Menz, "Valentin Carron versus Mai-Thu
 Perret im Centre d'Art Contemporain," *Kunst-
 Bulletin*, Zurich, no. 07/08, p. 58
 Alice Henkes, "Valentin Carron in der Galerie Francesca
 Pia," *Kunst-Bulletin*, Zurich, no. 03, p. 46
2004
 Lionel Bovier & Christophe Cherix, "Aperto Geneva,"
 Flash Art, Milan, May–June, p. 85–87
 Valentin Carron, Collection Cahiers d'Artistes, Pro
 Helvetia, Arts Council of Switzerland, Zurich
2002
 Gauthier Huber, "Les vertiges de la rétine," *Kunst-
 Bulletin*, Zurich, no. 3, p. 32–33
2001
 Mai-Thu Perret, "Valentin Carron, CAN, Neuchâtel,"
 frieze, London, no. 60, June–August, p. 115
 Lionel Bovier, *Across / Art/Suisse/1975–2000*, Skira,
 Milan/Geneva, p. 146–147

[p. 1] UNTITLED, 2000
C-print, edition of 7, 35 x 50 cm

[p. 2] SWEET REVOLUTION 2, 2003
polystyrene, fiberglass, acrylic resin and paint,
250 x 80 x 80 cm; collection of the artist

[p. 7] UNTITLED, 2004
polystyrene, fiberglass, acrylic resin and paint,
h: 300 cm x diam. 135 cm; courtesy Galerie Praz-
Delavallade, Paris

[p. 9] UNTITLED, 2003
polystyrene, fiberglass, acrylic resin and paint, plaster,
350 x 150 x 150 cm; private collection, Geneva

[p. 11] SWEET REVOLUTION, 2002
polystyrene, fiberglass, acrylic resin and paint,
Poppers bottles, 200 x 80 x 80 cm; private collection,
Geneva

[p. 12] KISS, 2005
MDF, acrylic paint, 220 x 175 x 175 cm; courtesy
Galerie Nosbaum & Reding, Art Contemporain,
Luxembourg

[p. 13] UNTITLED, 2003
polystyrene, fiberglass, acrylic resin and paint,
ghetto-blaster, sound, 260 x 80 x 80 cm; courtesy
Galerie Eva Presenhuber, Zurich

[p. 15] POISON INFILTRATION / AFTER THE SEPULTURE /
MACABRE OPERETTA / BLOOD RITUAL / WITH THE GLEAM
OF THE TORCHES / BESTIAL DEVOTION / DEFENSIVE
PERSONALITIES / UNTIL THE CHAOS, 2005
8 elements, polystyrene, fiberglass, acrylic resin and
paint, 30 x 30 x 100 cm (each); courtesy Galerie
Praz-Delavallade, Paris

[p. 17] PERGOLA, 2001
polystyrene, fiberglass, acrylic resin and paint,
225 x 350 x 350 cm; collection of the artist

[p. 18–19] RANCE CLUB II, 2006
wood, plasterboard, plaster, sound, 240 x 895 x 405 cm;
collection Ringier

[p. 20–21] BARRE BAR, 2005
iron, 110 x 262 x 19 cm; private collection, Luxembourg

[p. 23] AFTER THE HUNTING RUSH, 2002
polystyrene, fiberglass, acrylic resin and paint, red
wine, dimensions variable; private collection, Geneva

[p. 24] ORIFLAMMES, 2003
3 banners, 500 x 150 cm (each); private collection,
Basle

[p. 27] CHÂTEAU SYNTHÈSE, 2000
chemically produced wine, Jeroboam bottle, wax,
collection of the artist
UNTITLED, 2002
wood, enamel paint, 8 x 4 x 26 cm, edition of 12,
JRP Editions, Geneva

[p. 28] FOSBURY FLOP, 2006
polystyrene, fiberglass, acrylic resin and paint, 150 x
75 x 15 cm; courtesy Galerie Praz-Delavallade, Paris
UNTITLED (TRIBUTE TO ROBERT WADLOW), 2000
made-to-measure leather slippers, private collection,
Geneva
DEATH RACE 2000, 2000
tuned tricycle for disabled persons, various blades;
collection Fonds Cantonal d'Art Contemporain, Geneva

[p. 29] UNTITLED (PAVILION), 2003
polystyrene, fiberglass, acrylic resin and paint,
213 x 150 x 422 cm; collection of Michelle Nicol and
Rudolph Schürmann, Zurich
TURBO, 2000
restored ski-bobs, red wine, variable dimensions;
collection of the artist

[p. 30] ORIFLAMMES, 2003 (cf. p. 24)
PUZZOLA, 2004
polystyrene, fiberglass, acrylic resin and paint, ghetto-
blaster, sound, 71 x 83 x 90 cm; collection of the artist

[p. 33] BACK IN THE DAYS, 2005
digital print, aluminum, 90 x 128 cm; courtesy Galerie

Eva Presenhuber, Zurich
LOUD, 2005/ENGINE SWING, 2005/RUDE, 2005/
PRELUDE, 2005/THE BOOGIE, 2005: idem

[p. 35] UNTITLED, 2001
wood, marquetry, tuning mechanism, 100 x 26 x 12 cm;
collection Fonds Cantonal d'Art Contemporain, Geneva

[p. 36] UNTITLED, 2002
wood, paint on leather, 144 x 118 cm; collection Fonds
National d'Art Contemporain, Paris

[p. 37] UNTITLED, 2002
wood, paint on leather, green plant, 156 x 108 cm;
private collection

[p. 38] UNTITLED, 2004
wood, paint on leather, 80 x 60 cm; private collection,
London

[p. 39] UNTITLED (STILL LIFE WITH KEY), 2005
wood, paint on leather, 147 x 108 cm; private
collection, London

[p. 41] WESTERN, 2004
tire cover, tire, diam. 75 x 25 cm; private collection,
London

[p. 42] EAGLE, 2004
tire cover, tire, diam. 75 x 25 cm; courtesy Galerie Eva
Presenhuber, Zurich, and Evergreene, Geneva

[p. 43] WOLF, 2004
tire cover, tire, diam. 75 x 25 cm, edition of 2; courtesy
Galerie Eva Presenhuber, Zurich, and Evergreene,
Geneva

[p. 44] NO LOGO, 2003
coat hanger, five jackets embroidered with a silk
swastika, 85 x 50 x 40 cm; private collection

[p. 47] UNTITLED, 2003
wood, cotton, pine resin, leather, h: ca. 90 cm; private
collection

[p. 49] FORZA ETHIOPIA, 2006
polyurethan, epoxy resin, acrylic paint, metal,
220 x diam. 72 cm; private collection, London

[p. 50] RANCE CLUB, 2005
45 elements, wood, acrylic paint, metal, 240 x 30 x 30 cm
(each); courtesy Galerie Eva Presenhuber, Zurich

[p. 51] TO BE FRUIT, 2005
resin cast, acrylic paint, wall holder, 73 x 10 x 10 cm,
edition of 3; courtesy Galerie Eva Presenhuber, Zurich

[p. 53] L'HOSTILE, 2005
polyester, acrylic paint, 1 of 8 individual pieces,
300 x 46 x 70 cm; courtesy Galerie Eva Presenhuber,
Zurich

[p. 54] HATE ETERNAL, 2006
Tiflex paint on tarpaulin, metalic tubes, plastic straps,
180 x 240 cm; private collection

[p. 55] LASCIATEMI VIVERE LA MIA VITA, 2005
metal, polystyrene, fiberglass, acrylic resin and paint,
370 x 160 x 90 cm; courtesy Galerie Eva Presenhuber,
Zurich

[p. 56–57] CHIENS, 2006
wood, metalic structure, acrylic resin and paint,
46 x 70 x 15 cm (each); private collection, London

[p. 58] L' HOMME, 2006
wood, metalic structure, acrylic resin and paint,
190 x 110 x 30 cm; The Frank Mosvold Collection

[p. 59] LA MAIN, 2006
wood, metalic structure, acrylic resin and paint,
45 x 70 x 10 cm; private collection, New York

[p. 60] BLIND BEAR, 2000
polystyrene, fiberglass, acrylic resin and paint,
330 x diam. 90 cm; collection Mamco, Geneva

[p. 64] OVALE, 2004
polystyrene, fiberglass, acrylic resin and paint,
113 x 79 x 16 cm, edition of 3; courtesy Galerie
Praz-Delavallade, Paris

This monograph is published on the occasion of the exhibitions *Mai-Thu Perret versus Valentin Carron. Solid Objects*, Centre d'art contemporain Genève, Geneva (May 20—August 14, 2005) and *Valentin Carron*, Kunsthalle Zürich, Zurich (January 20—March 18, 2007).

EXHIBITIONS

Centre d'art contemporain Genève, Geneva

DIRECTOR Katya García-Antón

ADMINISTRATION Geneviève Froidevaux
PUBLIC RELATIONS AND PRESS Jane van Lanschot
Hubrecht
PROJECT COORDINATOR Denis Pernet
SECRETARIAT Cendrine Pouzet

Centre d'art contemporain Genève
10, rue des Vieux-Grenadiers
CH-1205 Geneva
T +41 (0)22 329 18 42
F +41 (0)22 329 18 86
www.centre.ch

The Centre d'art contemporain would like to thank the
Department of Cultural Affairs of the city of Geneva; the
French Embassy in Switzerland; the Foundation Bea for
young artists; the Conseil de la Culture, Etat du Valais;
and Pro Helvetia.

Kunsthalle Zürich, Zurich

DIRECTOR / CURATOR Beatrix Ruf

EXHIBITION ASSISTANCE Samuel Leuenberger
ASSISTANCE Beatrice Steiner
COMMUNICATION AND PRESS Susanne Stortz
IT AND ADMINISTRATION Alfonso Negri
TECHNICAL TEAM Attila Panczel, Silvan Goette, Basil
Kobert, Boris Knorpp, Tobias Spichtig, Rachel Stänz,
Oliver Stäudlin, Nina Weber
CASHIER Rahel Blättler, Nadine Hofer, Anna Leuenberger,
Silvie Zürcher

Kunsthalle Zürich
Limmatstrasse 270
CH-8005 Zurich
T +41 (0)44 272 15 15
F +41 (0)44 272 18 88
E info@kunsthallezurich.ch
www.kunsthallezurich.ch

The Kunsthalle Zürich would like to thank for their
continuous support:
Präsidialdepartement der Stadt Zürich; Luma Foundation;
and Swiss Re, Zurich.

PUBLICATION

EDITORS Katya García-Antón, Beatrix Ruf
EDITING AND PROOFREADING Clare Manchester
EDITORIAL COORDINATION Beatrice Steiner, Birte Theiler
TRANSLATIONS Mai-Thu Perret, John Lee, Judith Hayward
DESIGN Gavillet & Rust, Geneva
TYPEFACE Hermes (www.optimo.ch)
COVER *Untitled*, 2005 (detail)
PHOTOGRAPHS A. Burger, Marc Domage, Pierre Fantys,
André Morin
COLOUR SEPARATION & PRINT Musumeci S.p.A.—Quart (Aosta)

The publication has received the generous support from:
Conseil de la Culture, Etat du Valais

Printed in Europe.

PUBLISHED BY
JRP|Ringier
Letzigraben 134
CH-8047 Zurich
T +41 (0)43 311 27 50
F +41 (0)43 311 27 51
E info@jrp-ringier.com
www.jrp-ringier.com

ISBN 13: 978-3-905701-53-1

ALSO AVAILABLE
German edition: ISBN 13: 978-3-905770-49-0
French edition: ISBN 13: 978-3-905770-50-6

JRP|Ringier books are available internationally at selected
bookstores and from the following distribution partners:

UK
Art Data, 12 Bell Industrial Estate, 50 Cunnington Street,
UK-London W4 5HB, info@artdata.co.uk, www.artdata.co.uk

USA
D.A.P./Distributed Art Publishers, 155 Sixth Avenue,
2nd Floor, USA-New York, NY 10013, dap@dapinc.com,
www.artbook.com

OTHER COUNTRIES
IDEA Books, Nieuwe Herengracht 11, NL-1011 RK Amsterdam,
idea@ideabooks.nl, www.ideabooks.nl

For a list of our partner bookshops or for any
general questions, please contact JRP|Ringier directly
at info@jrp-ringier.com, or visit our homepage
www.jrp-ringier.com for further information about
our program.

KULTURRAT
DES KANTONS WALLIS

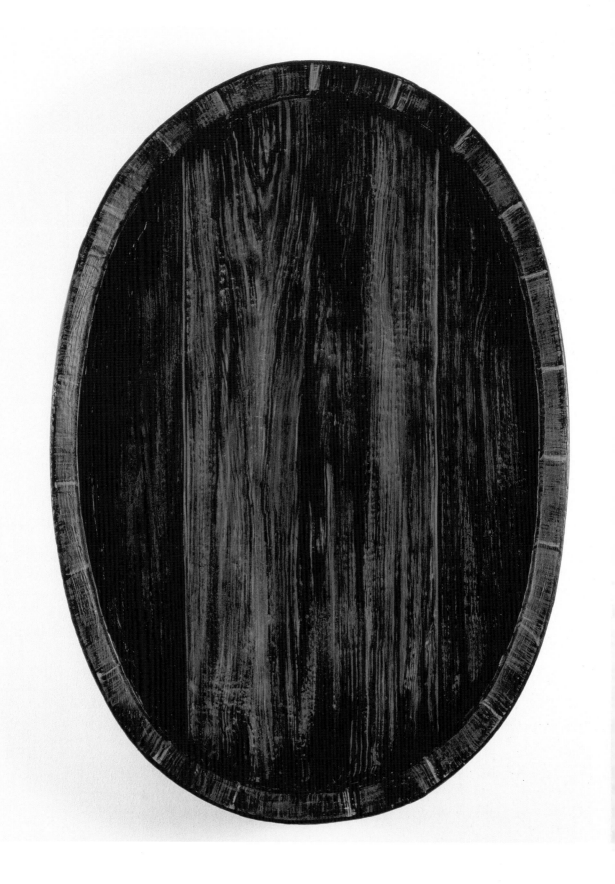

OVALE, 2004